MYTHIC WORLD

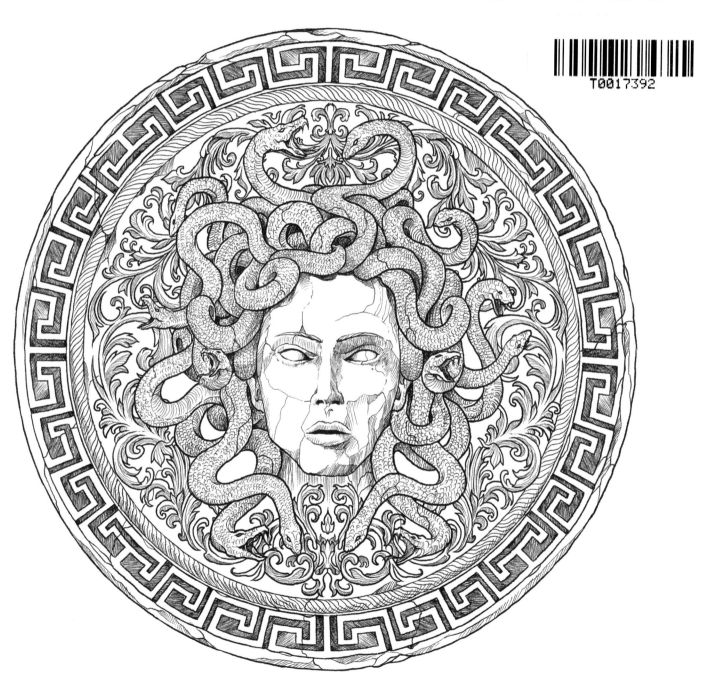

ILLUSTRATED BY

KERBY ROSANES

THIS BOOK BELONGS TO

..

WRITTEN AND EDITED BY JOSEPHINE SOUTHON
DESIGNED BY JADE MOORE
COVER DESIGN BY JOHN BIGWOOD

PLUME
An imprint of Penguin Random House LLC
penguinrandomhouse.com

W www.mombooks.com
f Michael O'Mara Books
y OmaraBooks
lomart books

Trade paperback ISBN: 9780593186022

Printed in China
2nd Printing

A MYTHICAL AND MAGICAL EXPERIENCE AWAITS...

Venture with me into a parallel world,
where familiar landscapes come to life with
gods and goddesses, monsters and spirits.
This is legend as you've never seen it before.

Each intricate illustration has been
crafted with fineliner pens and can
be colored in any way you like.

Find out more information about
each myth at the back of the book.

Kerby Rosanes

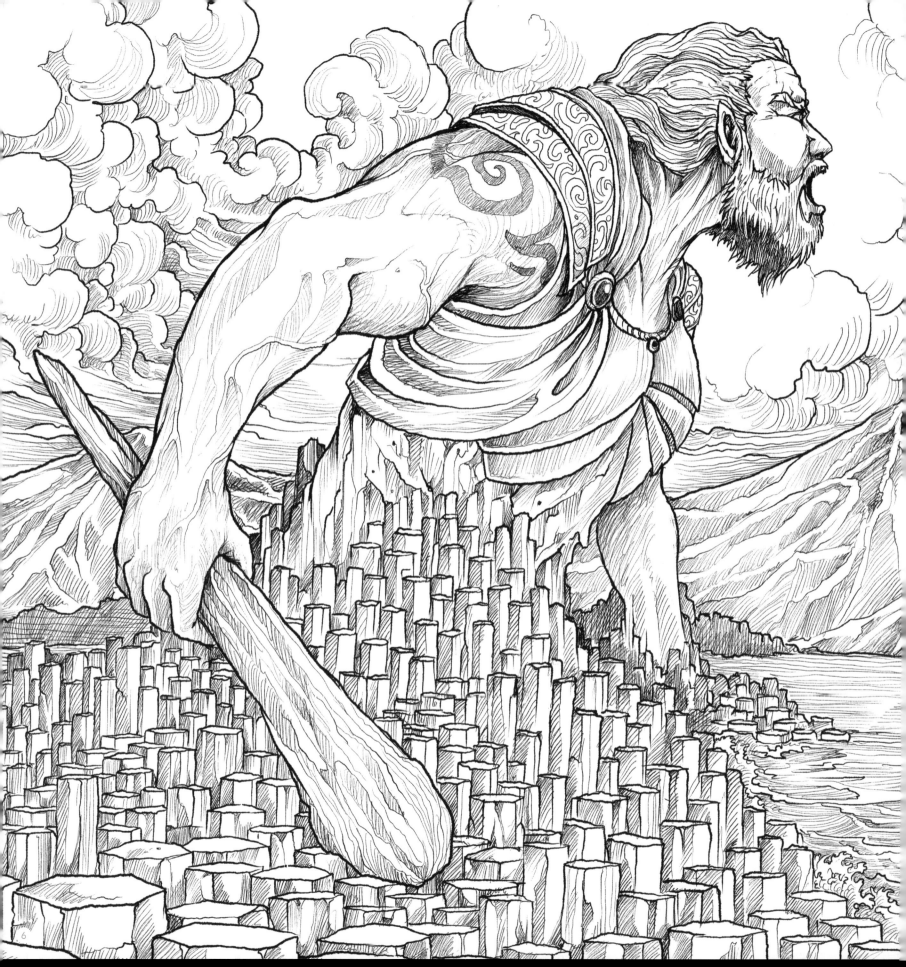

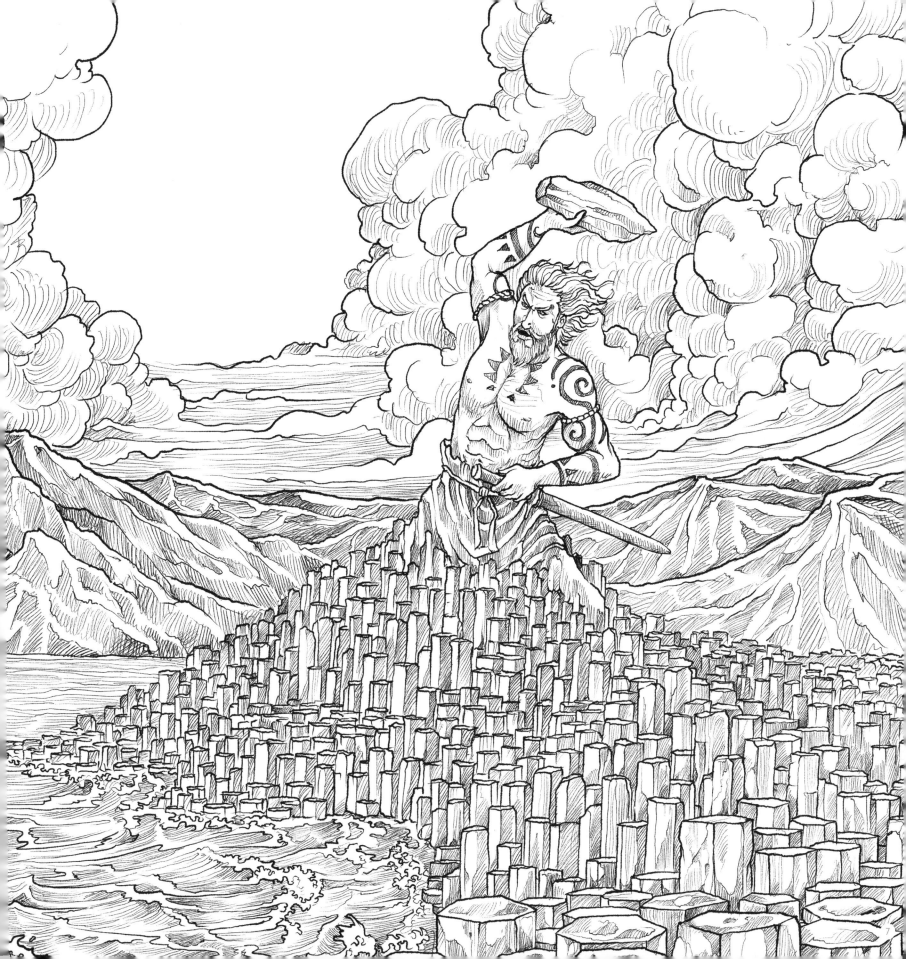

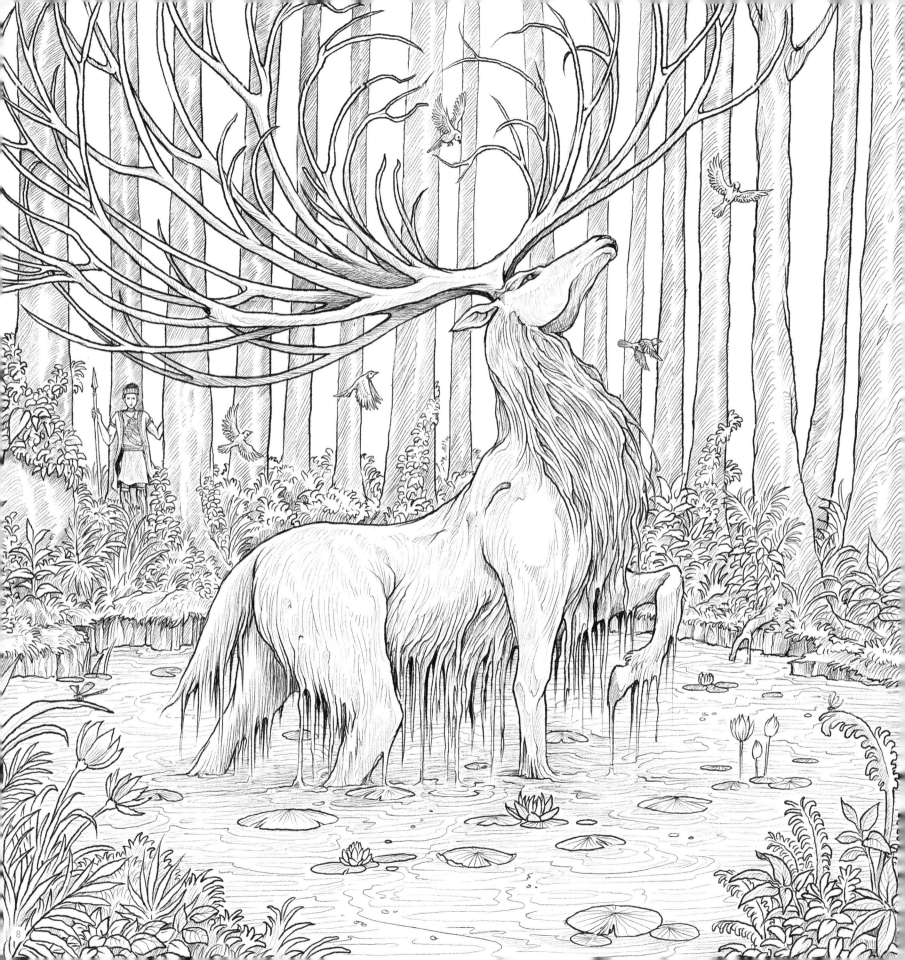

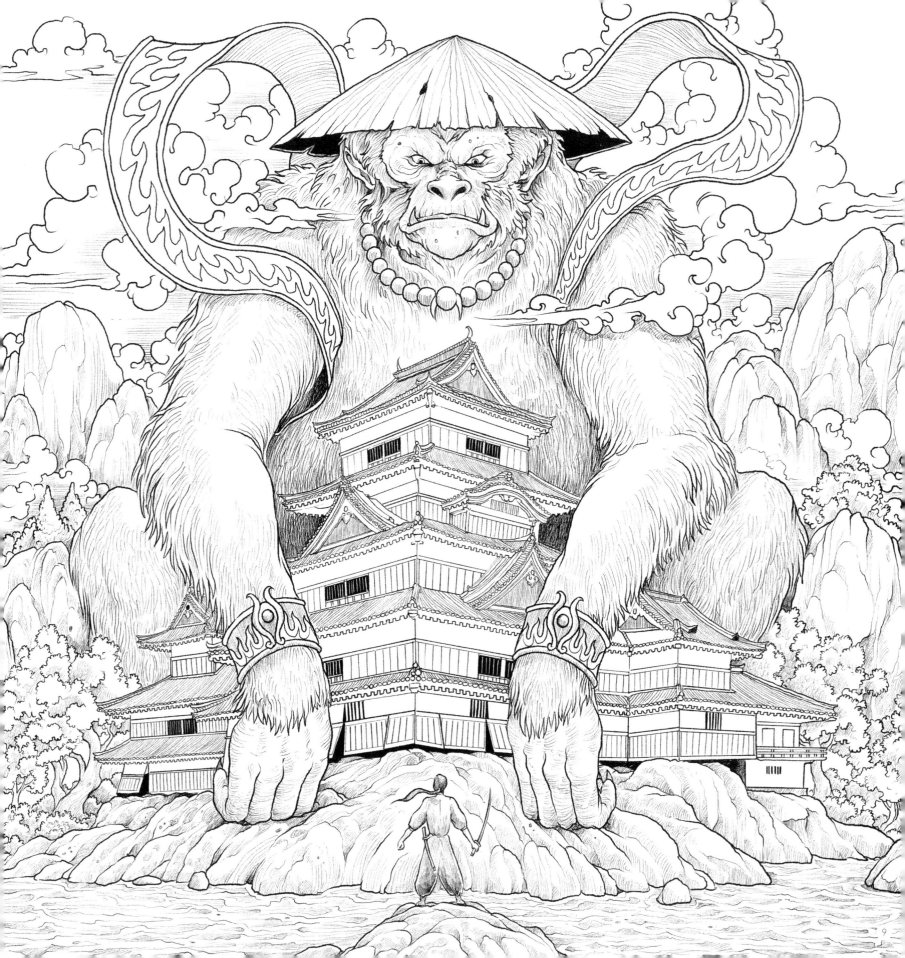

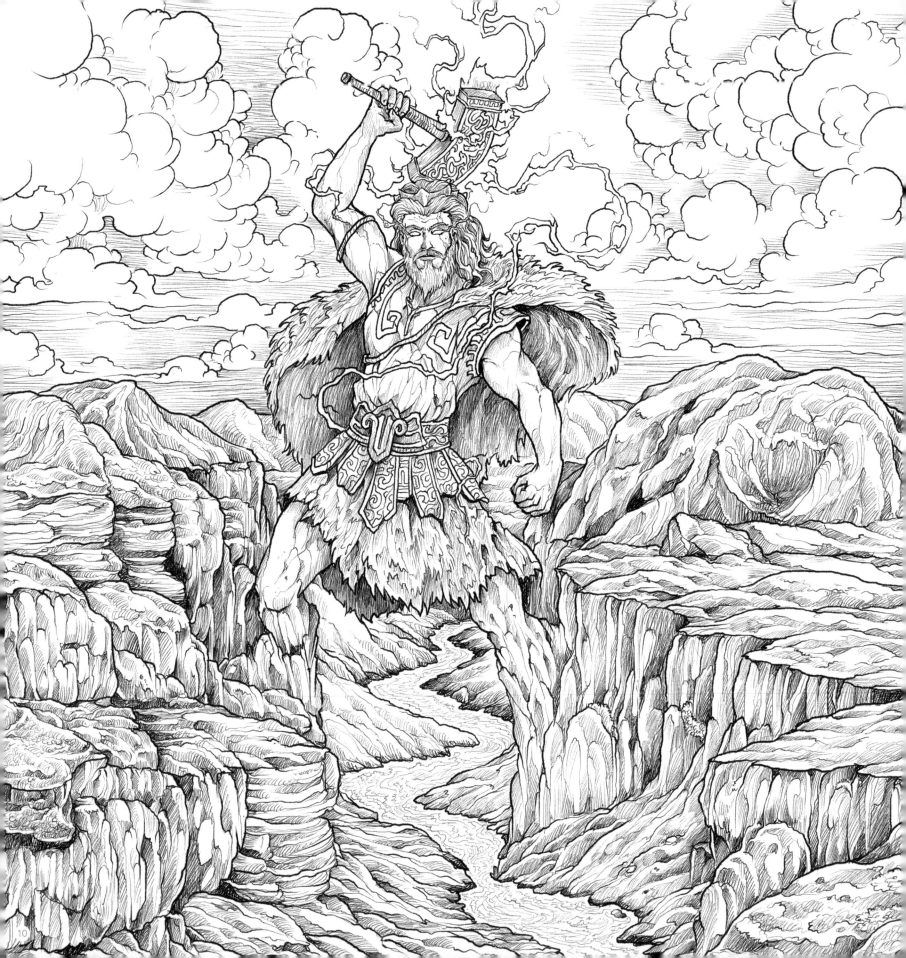

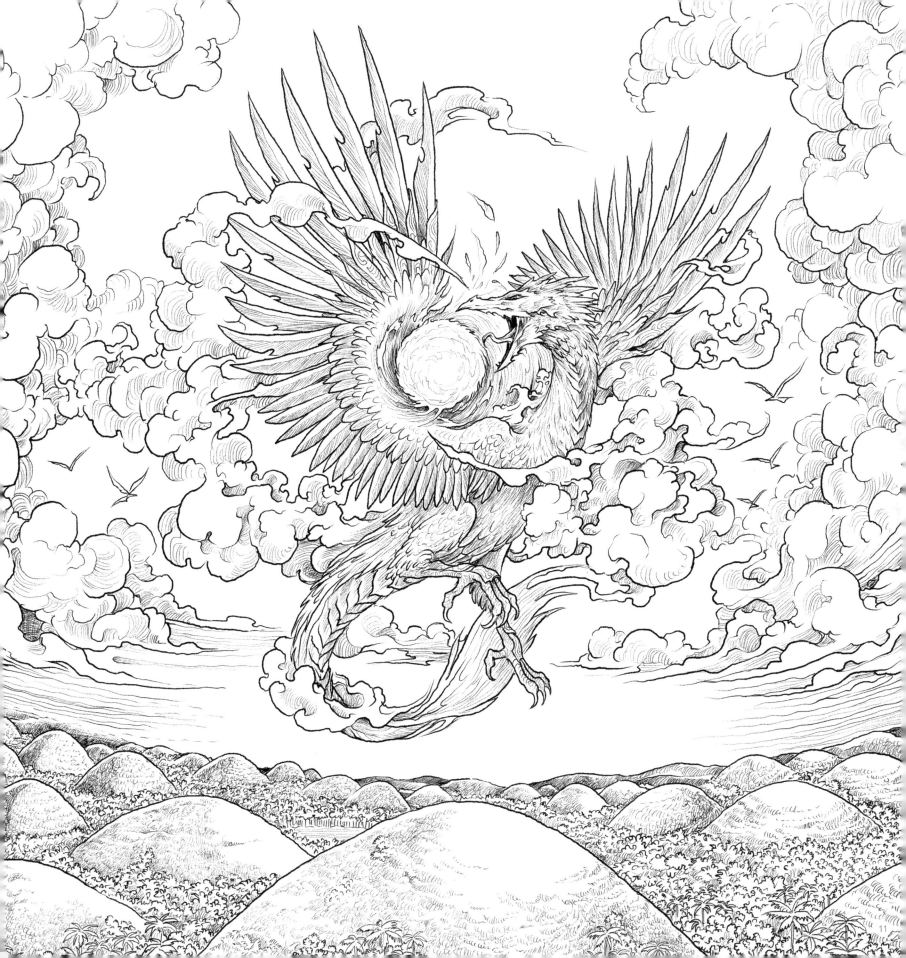

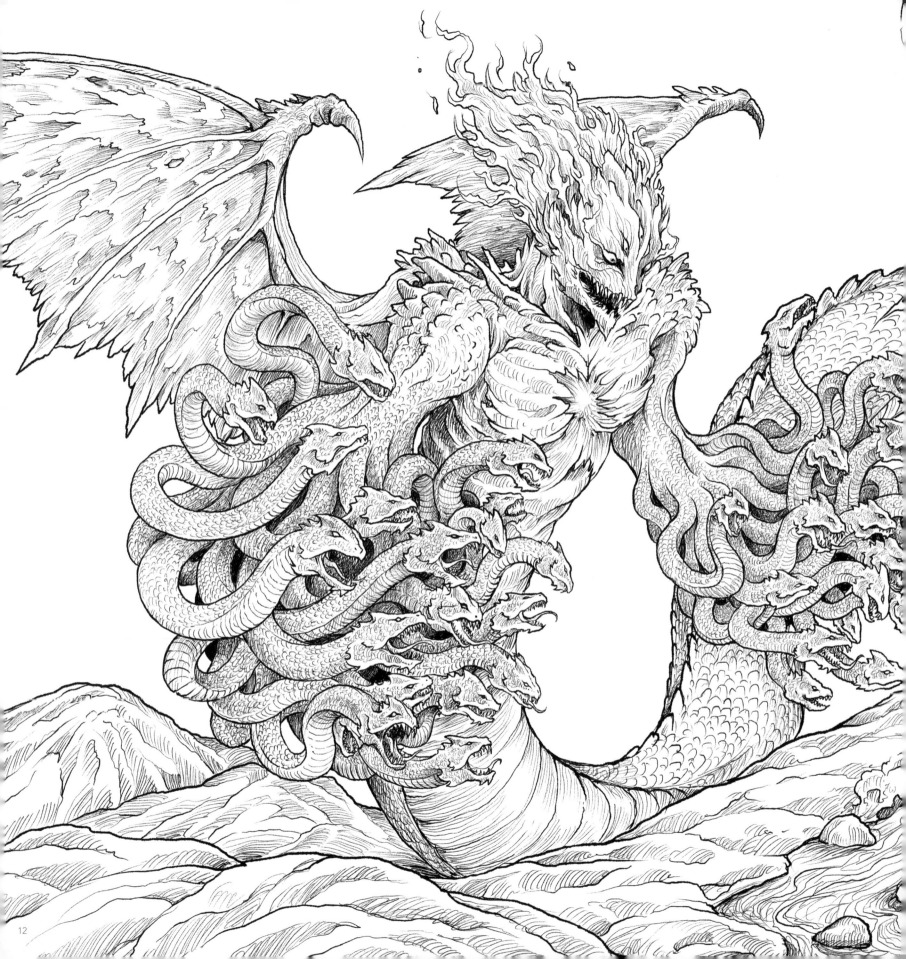

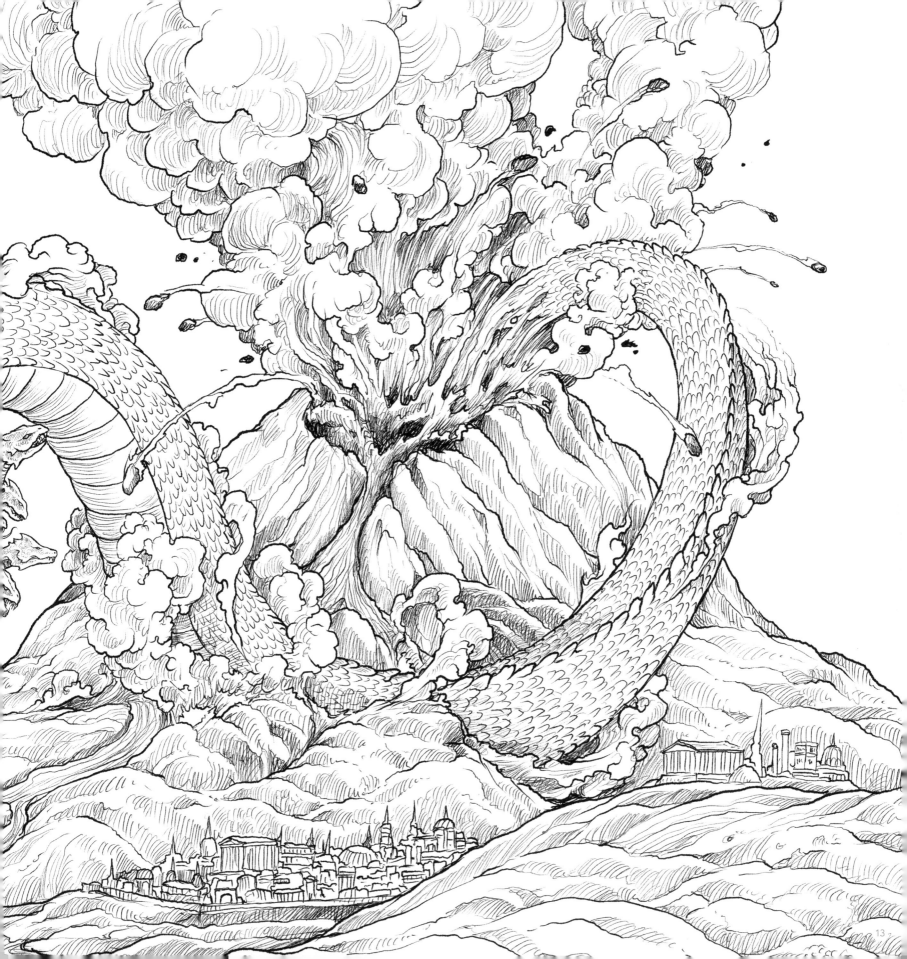

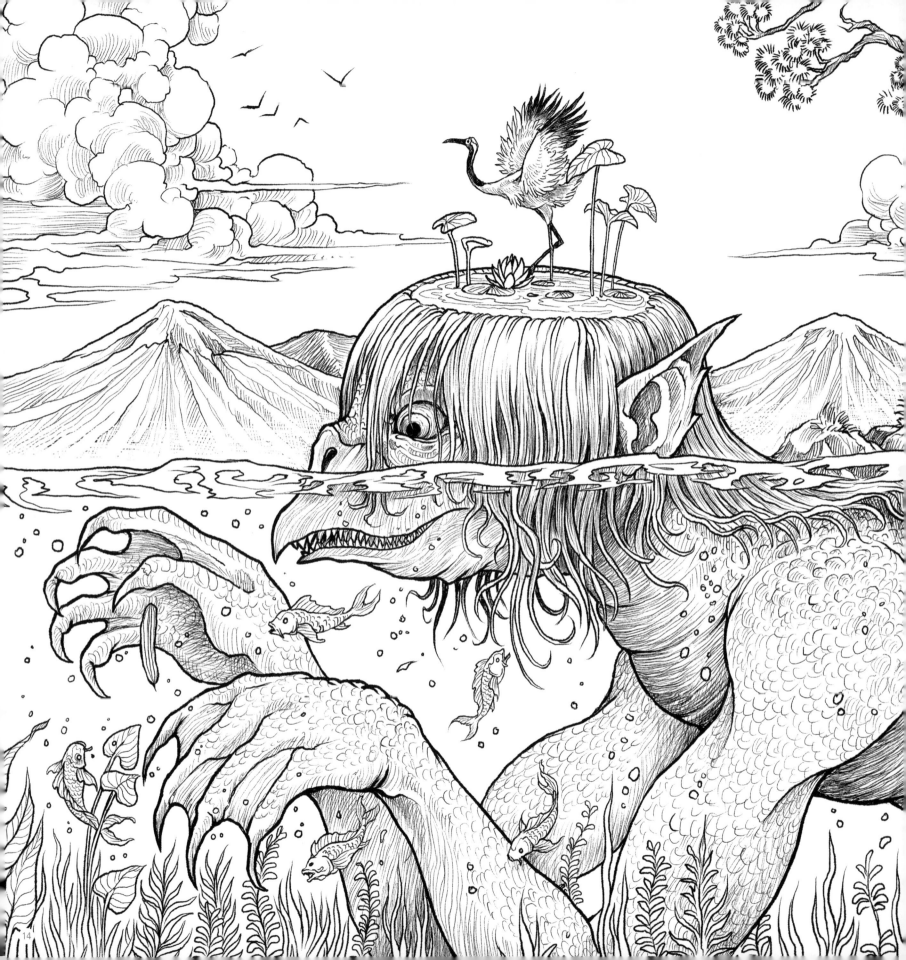

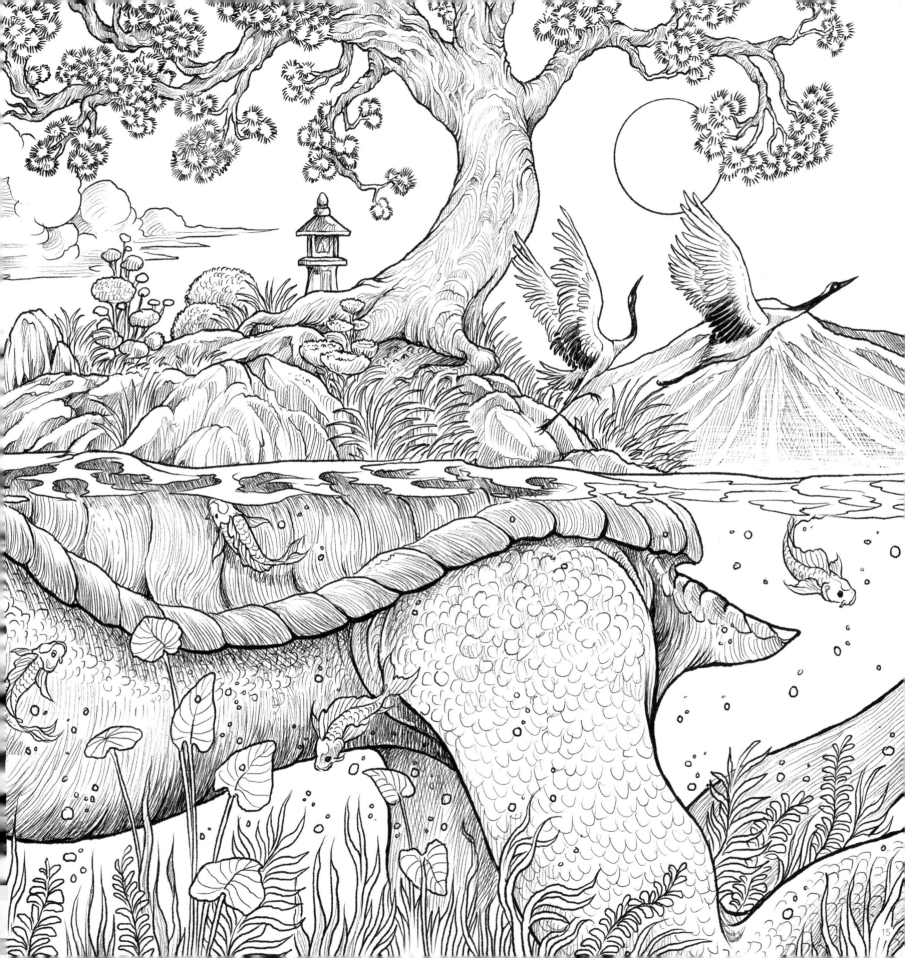

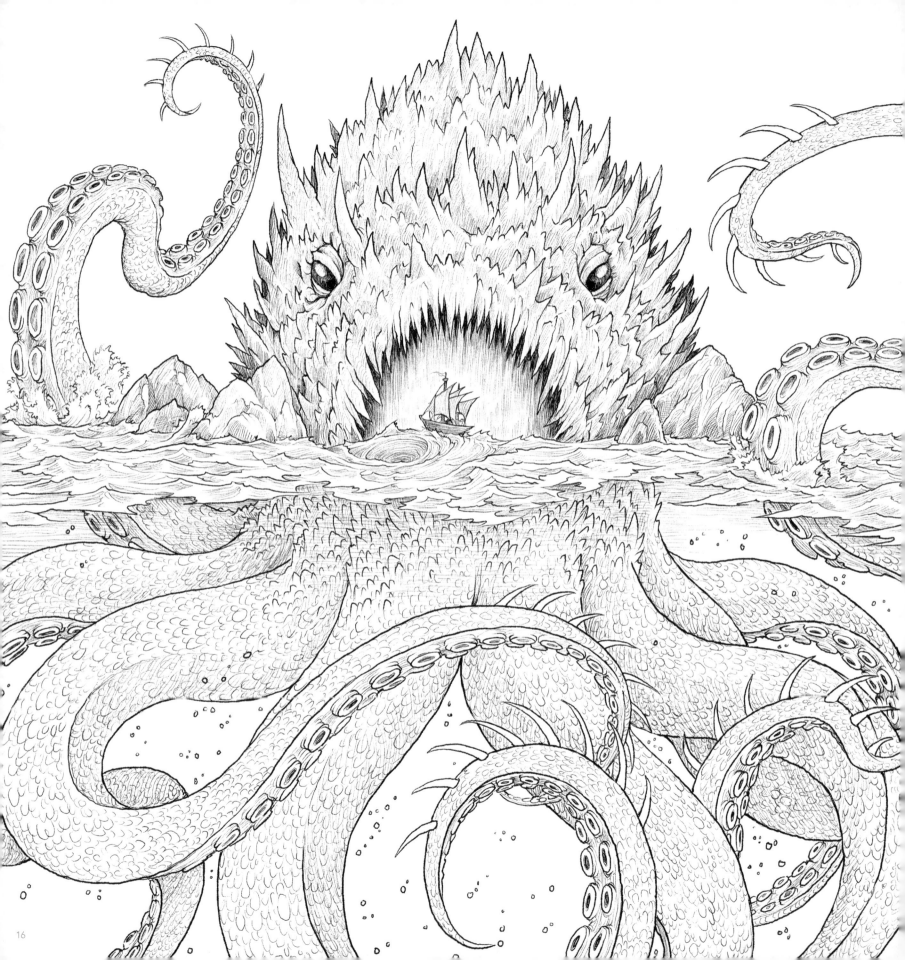

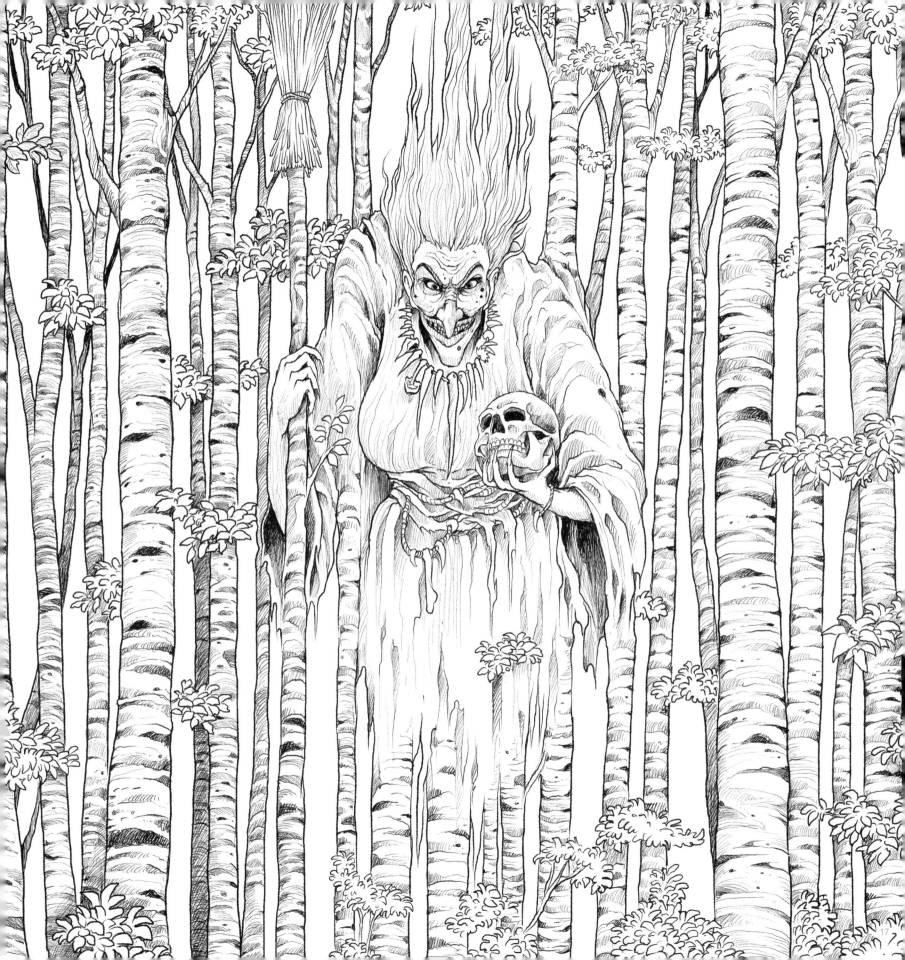

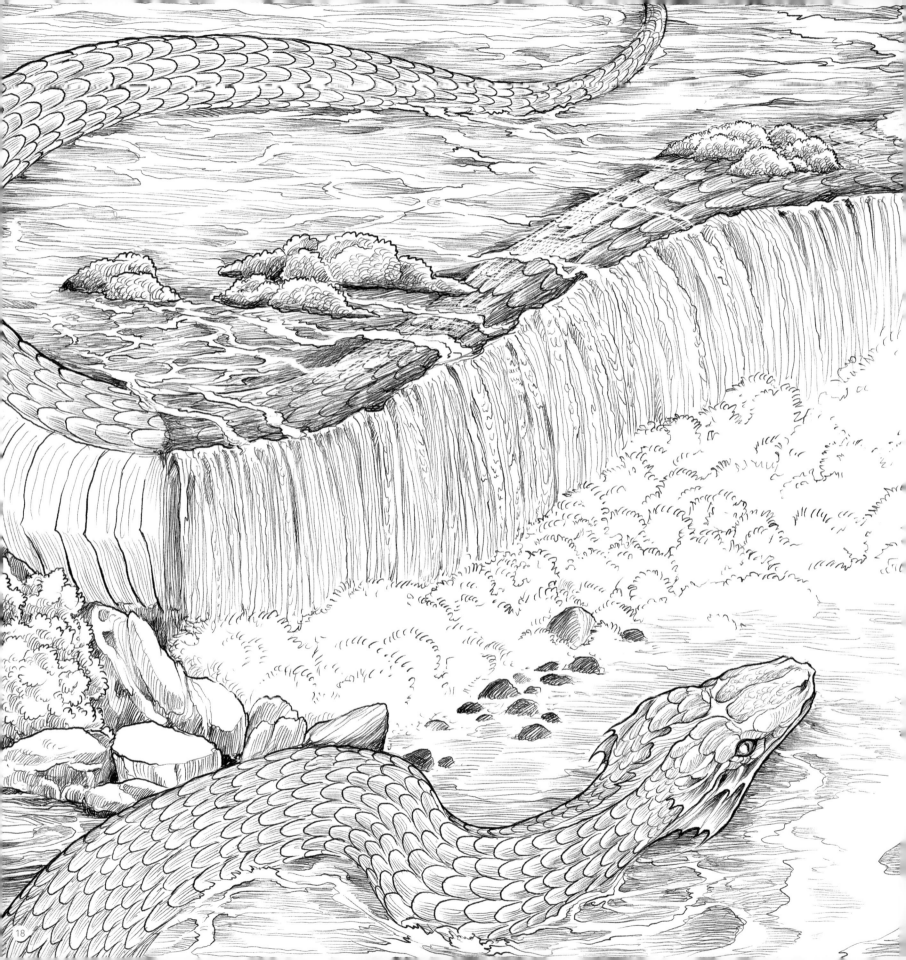

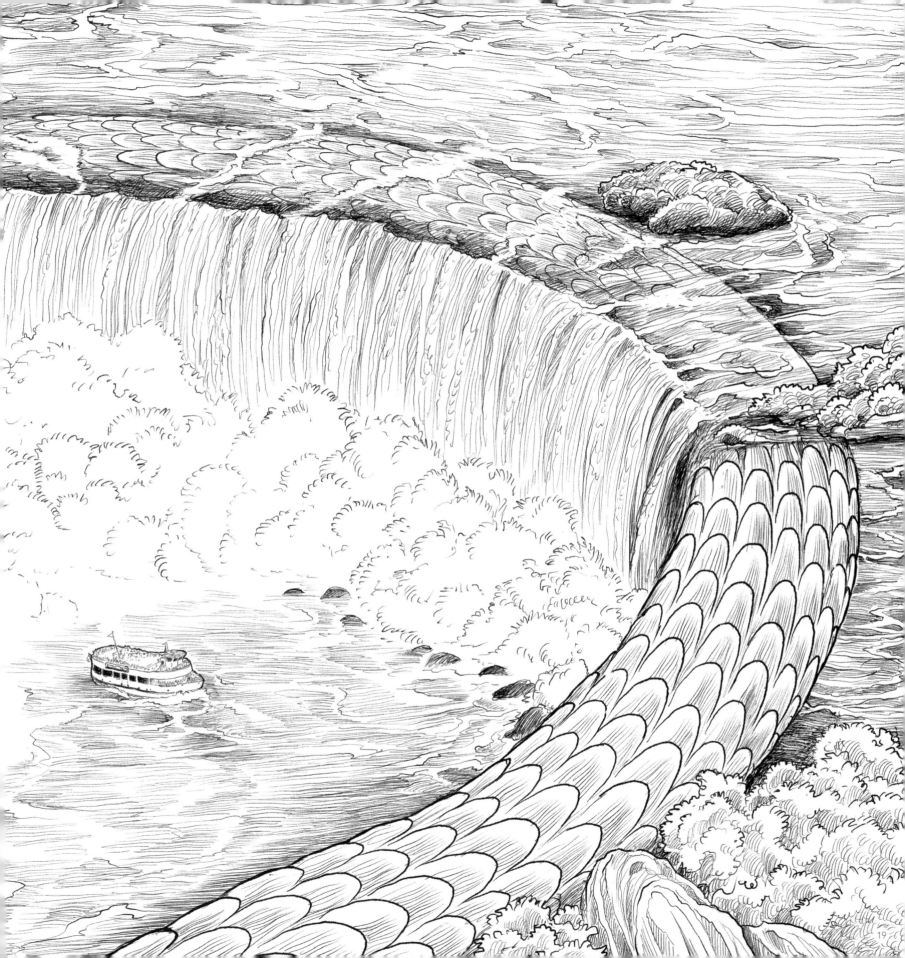

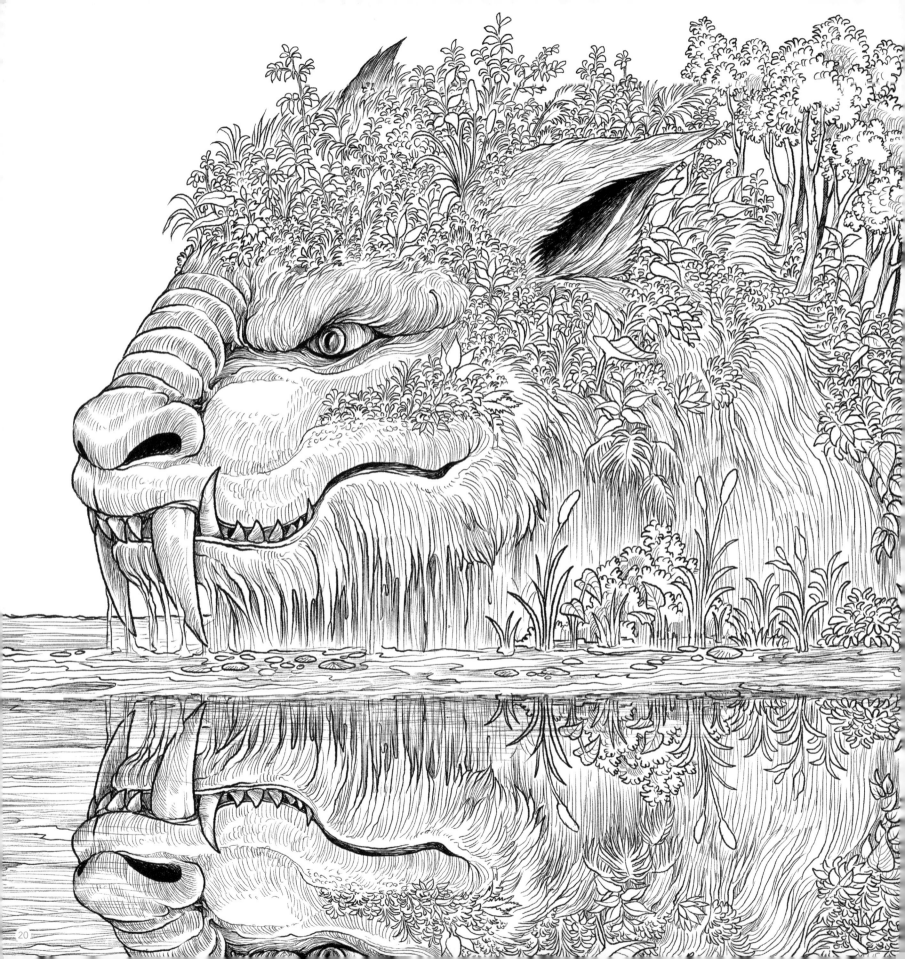

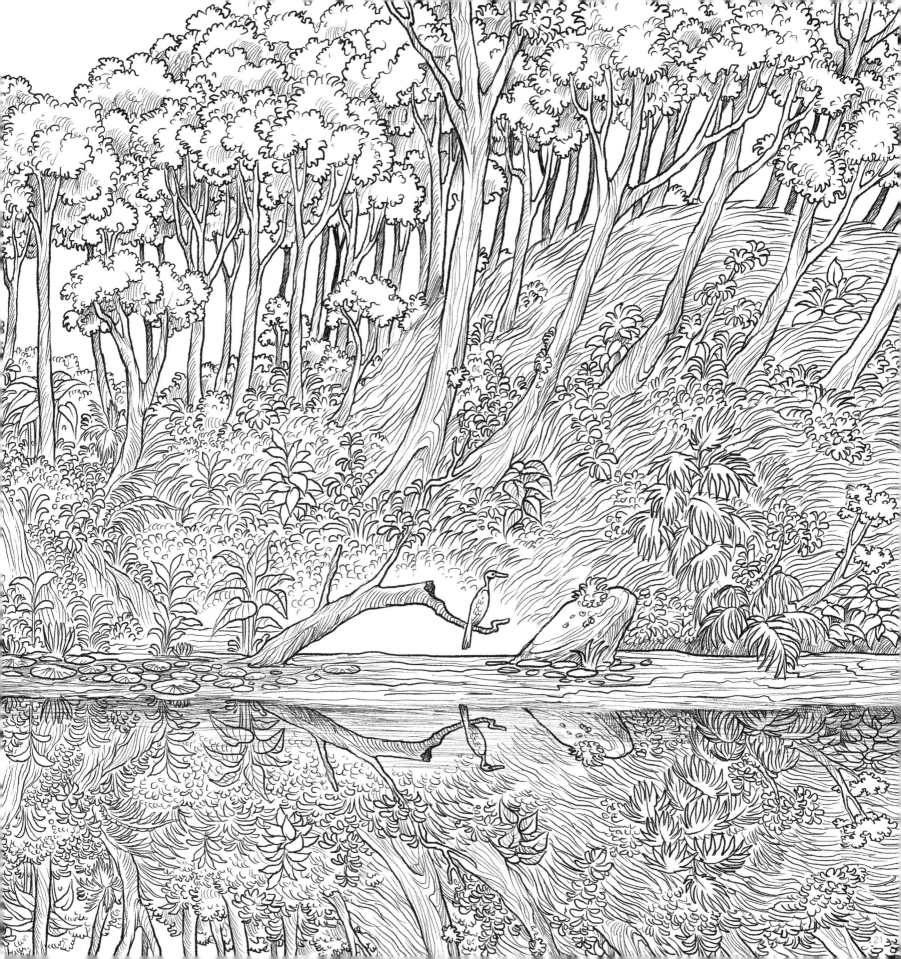

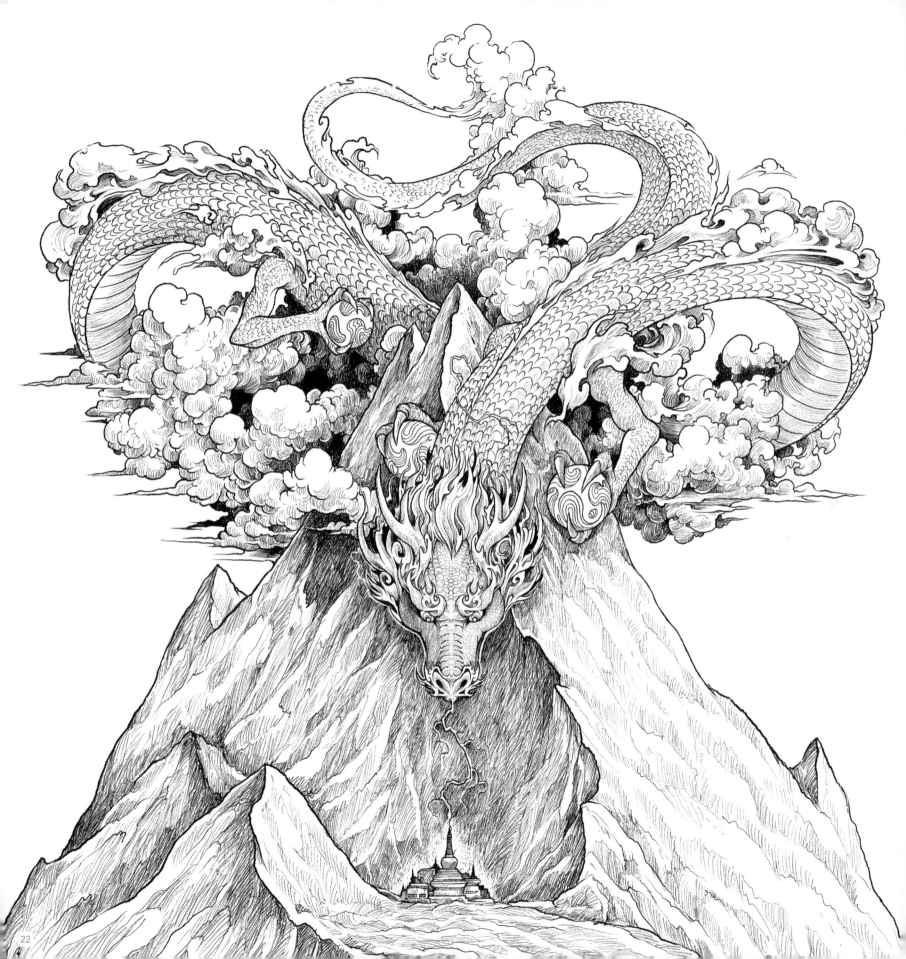

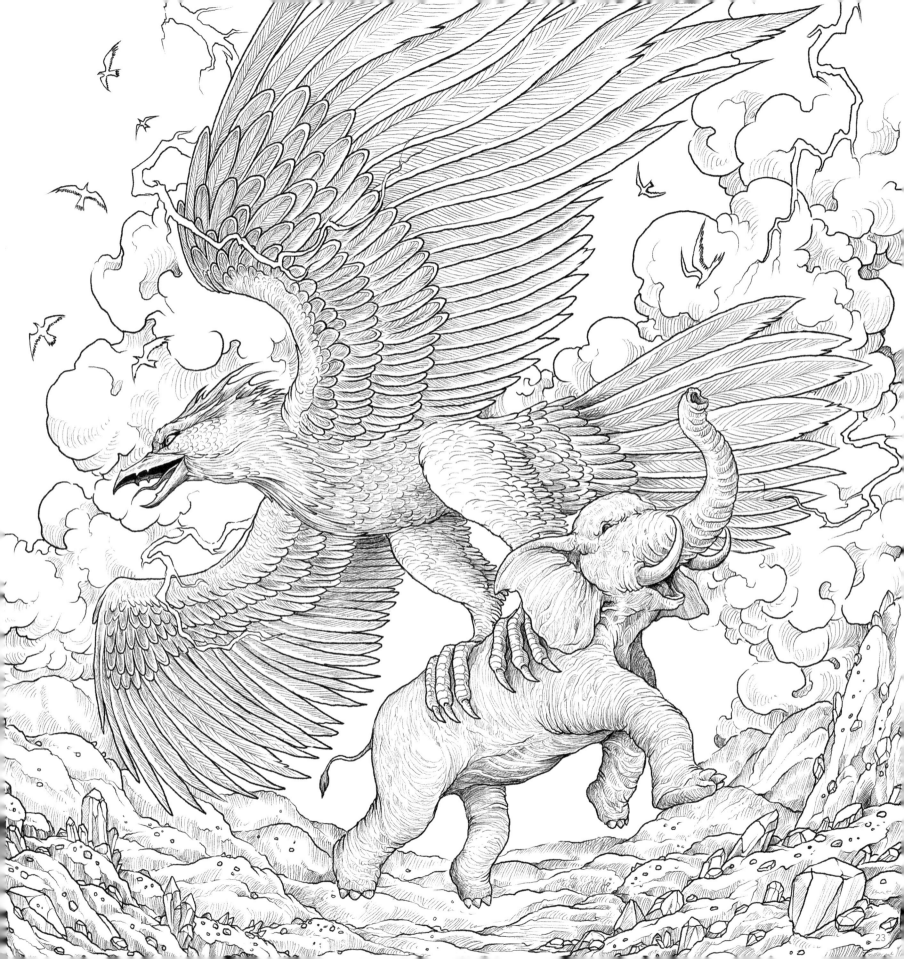

23

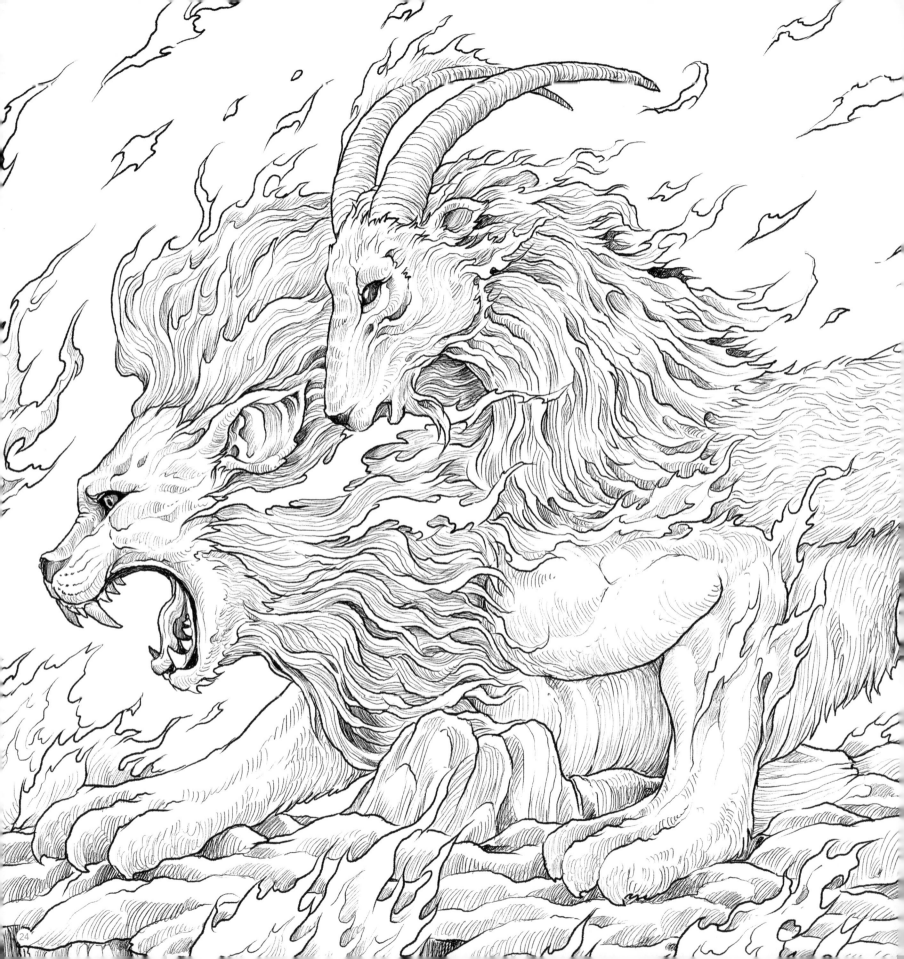

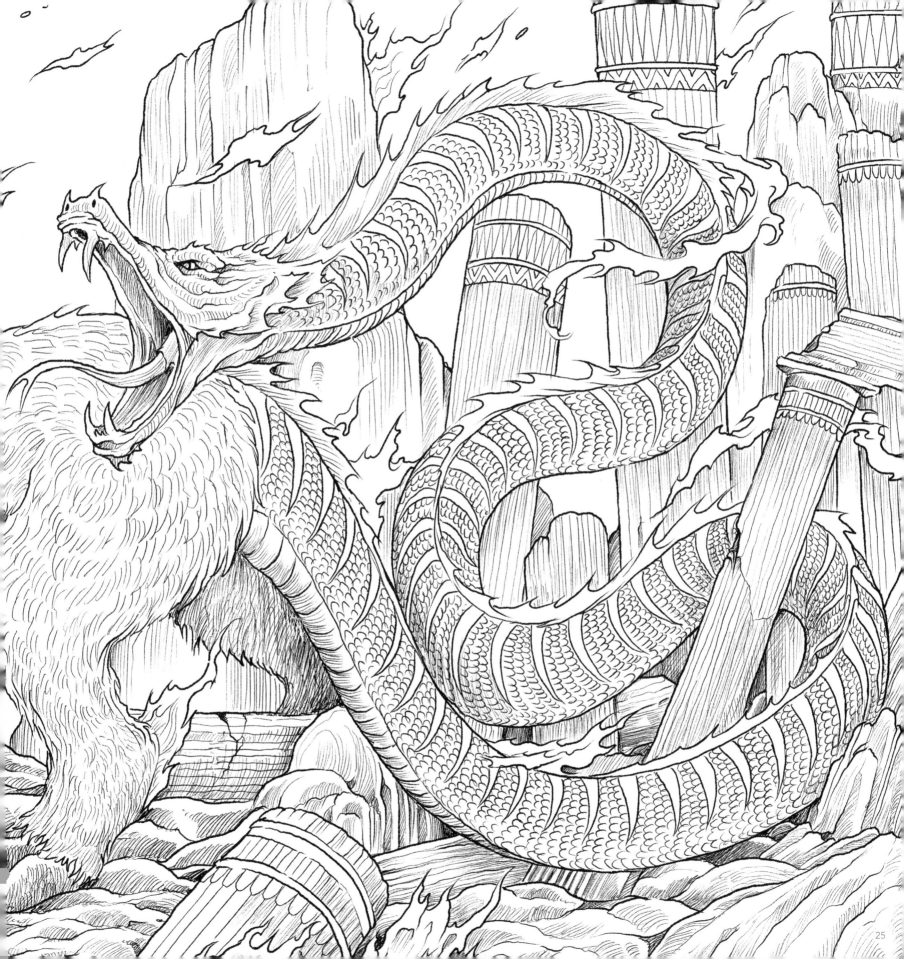

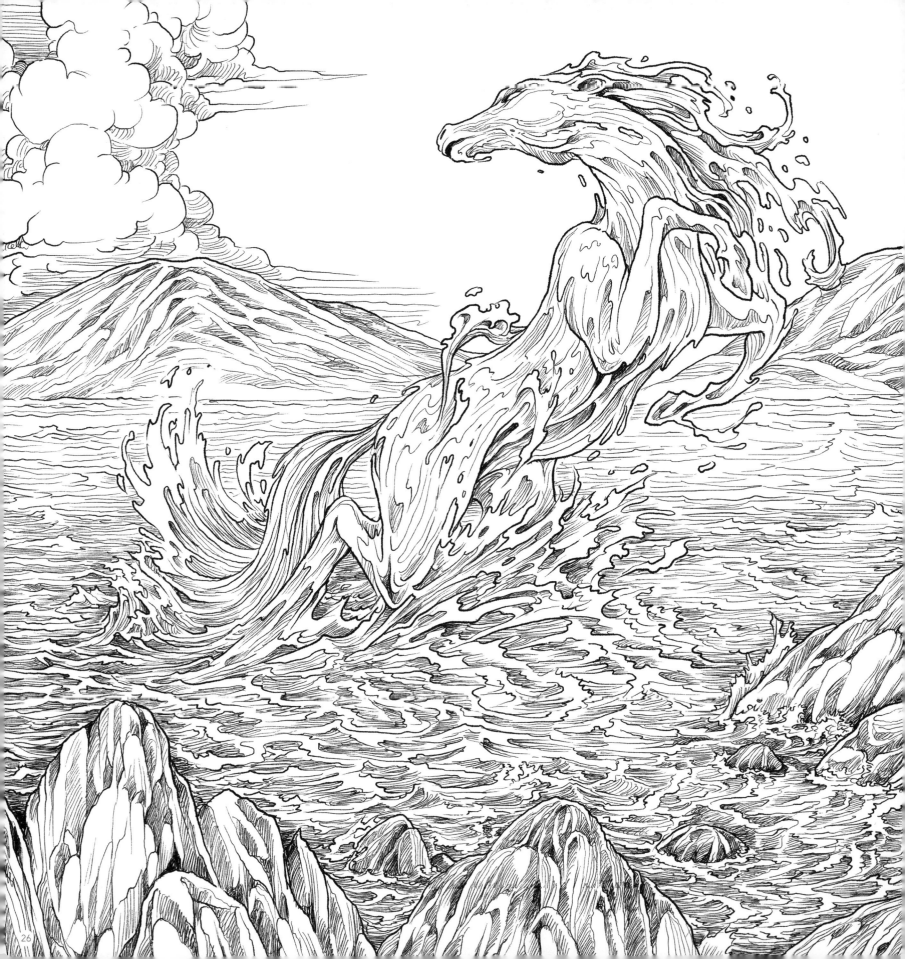

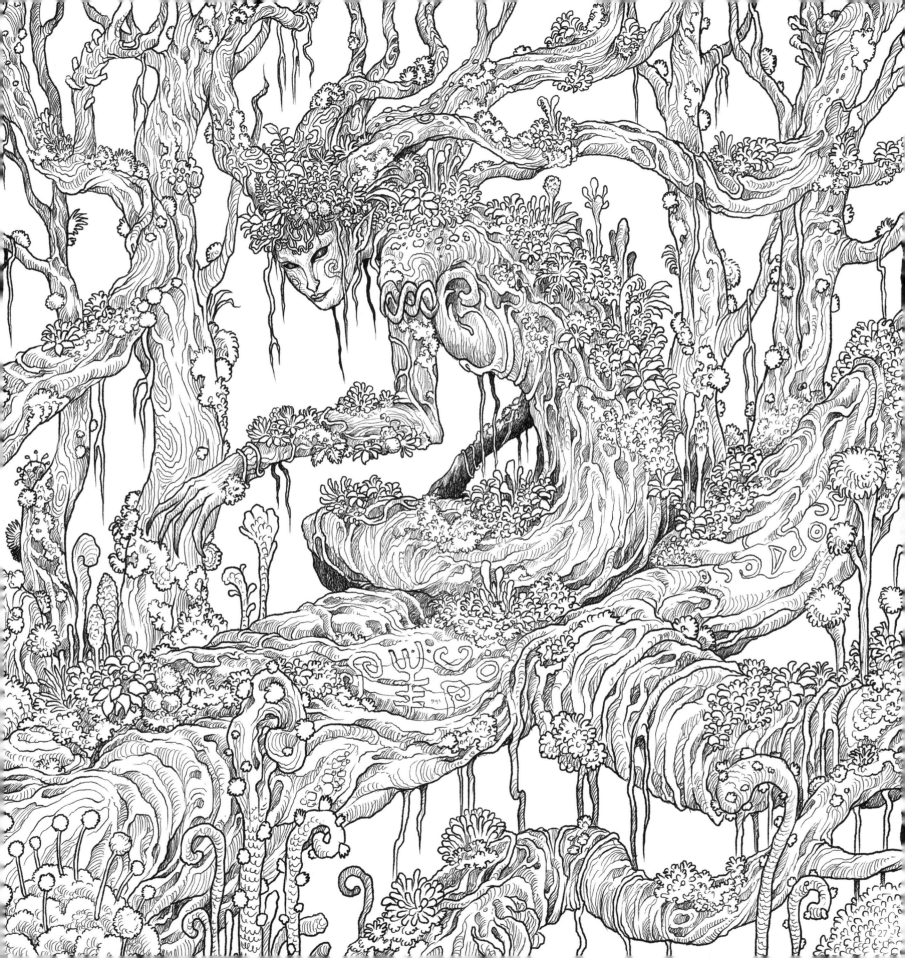

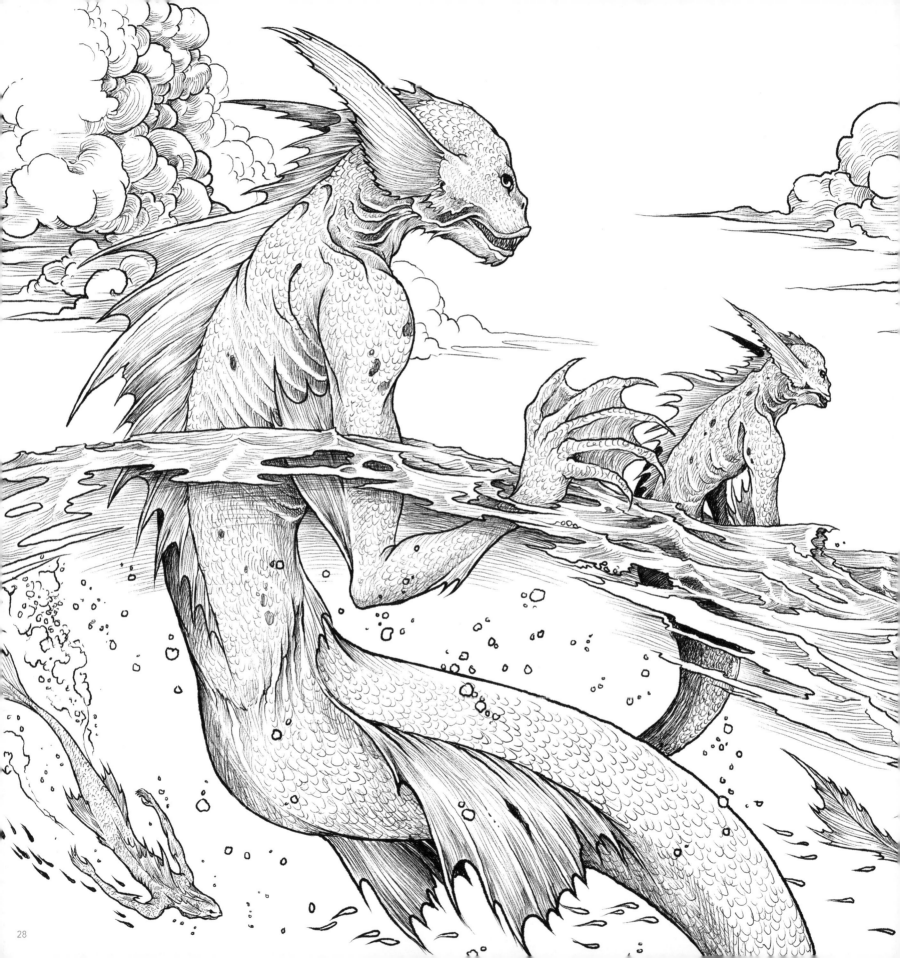

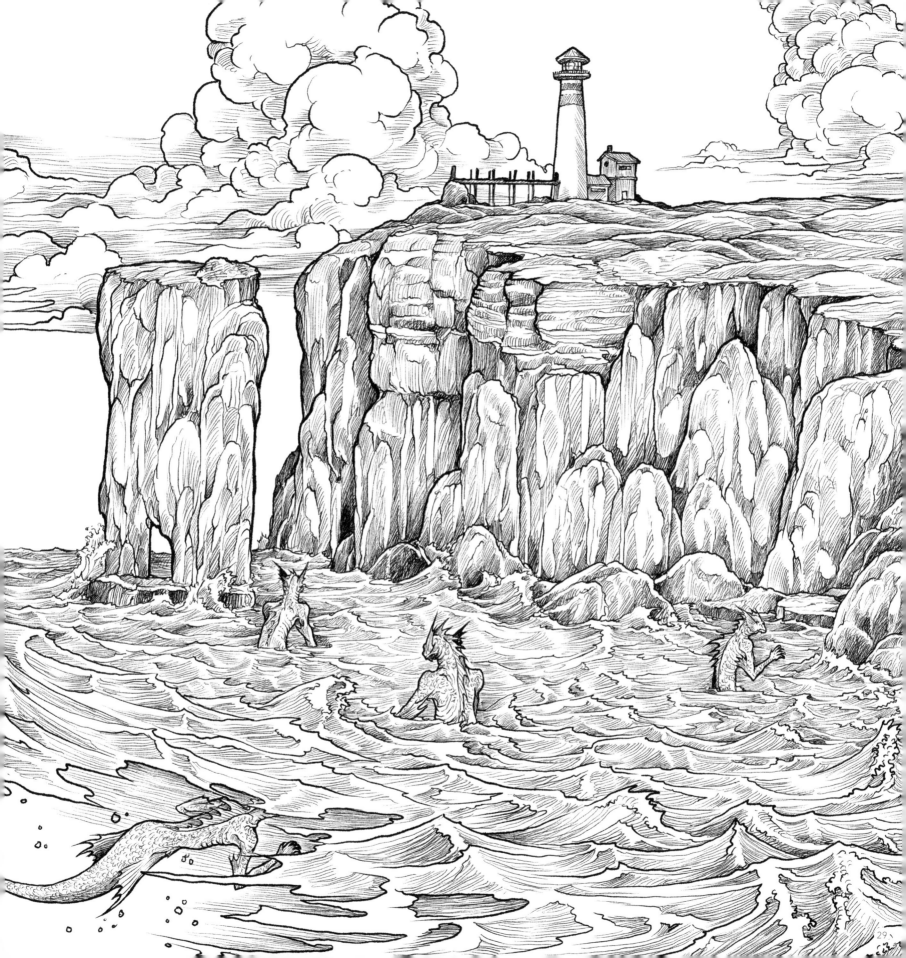

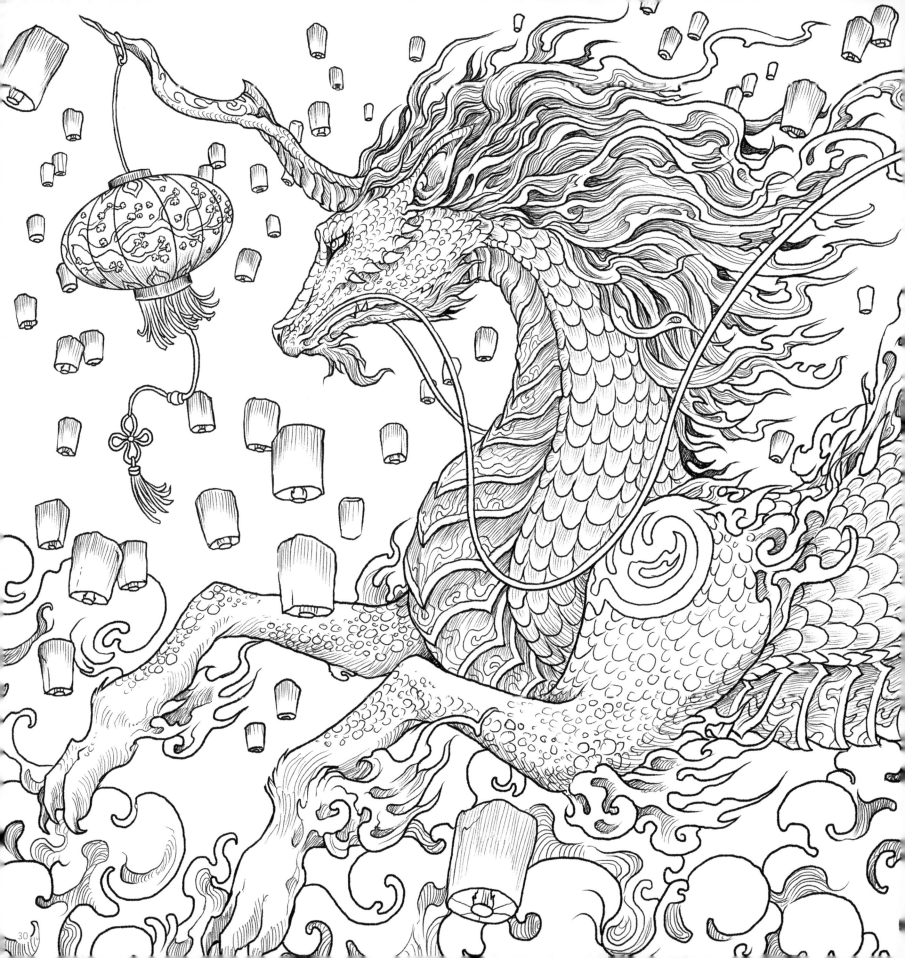

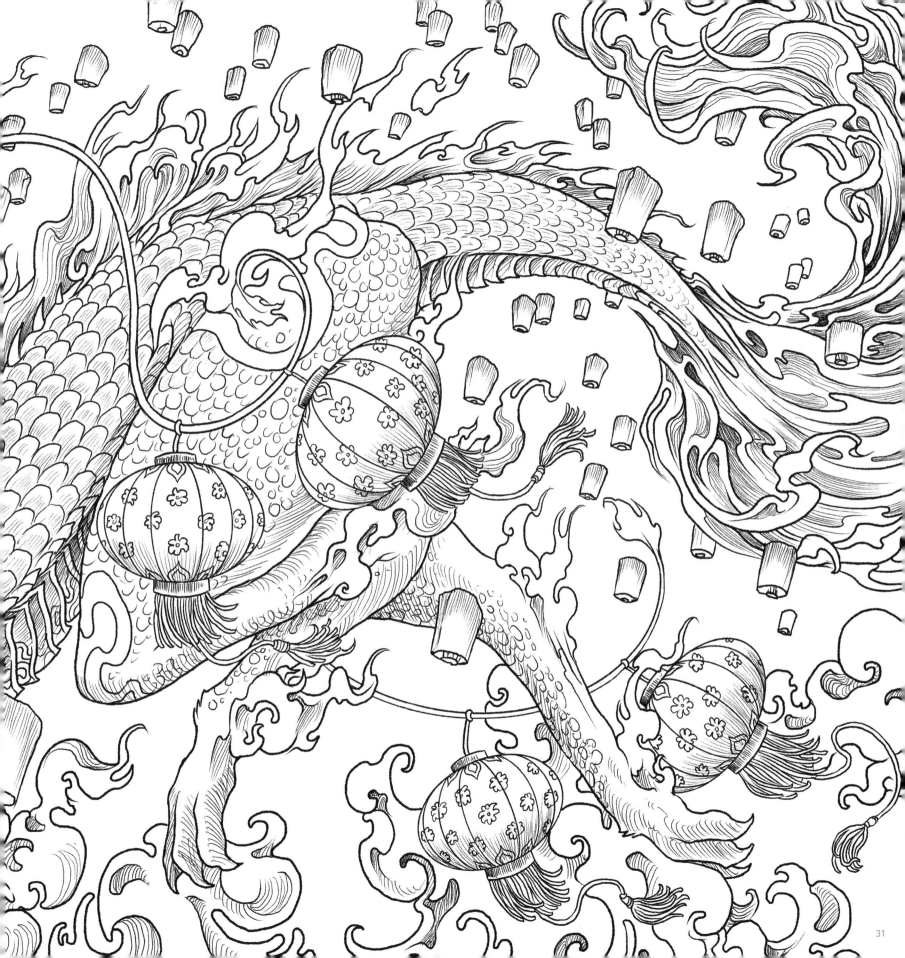

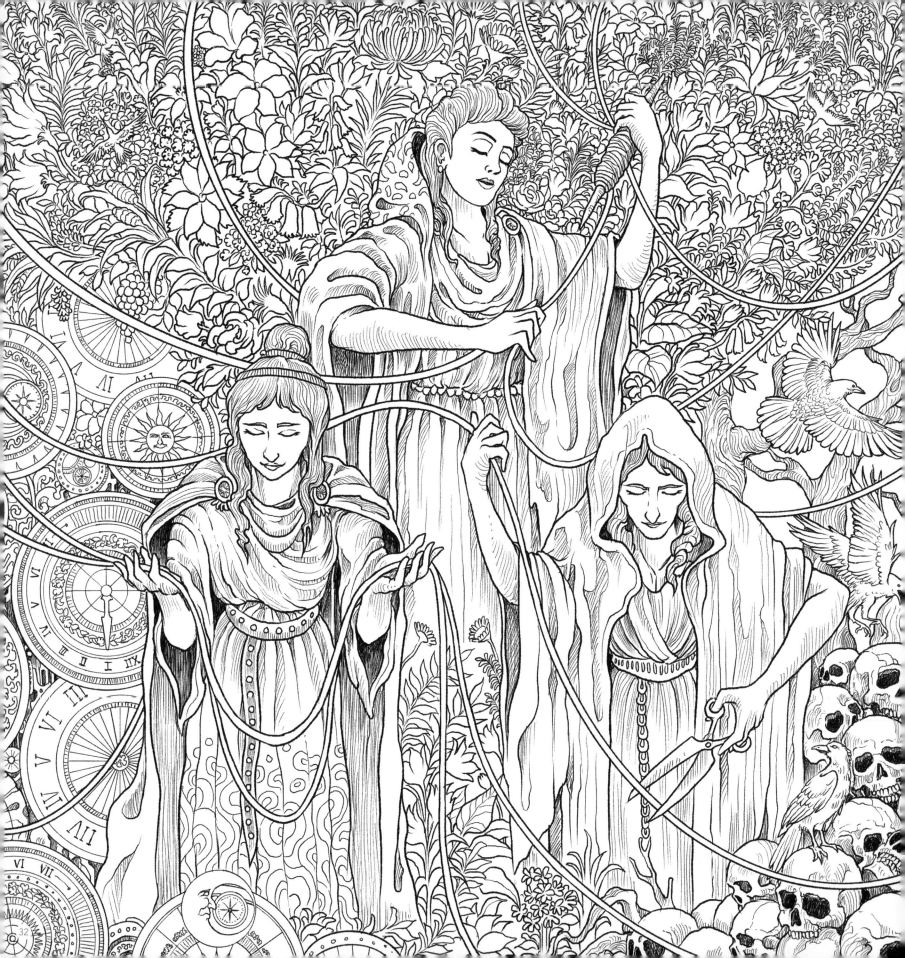

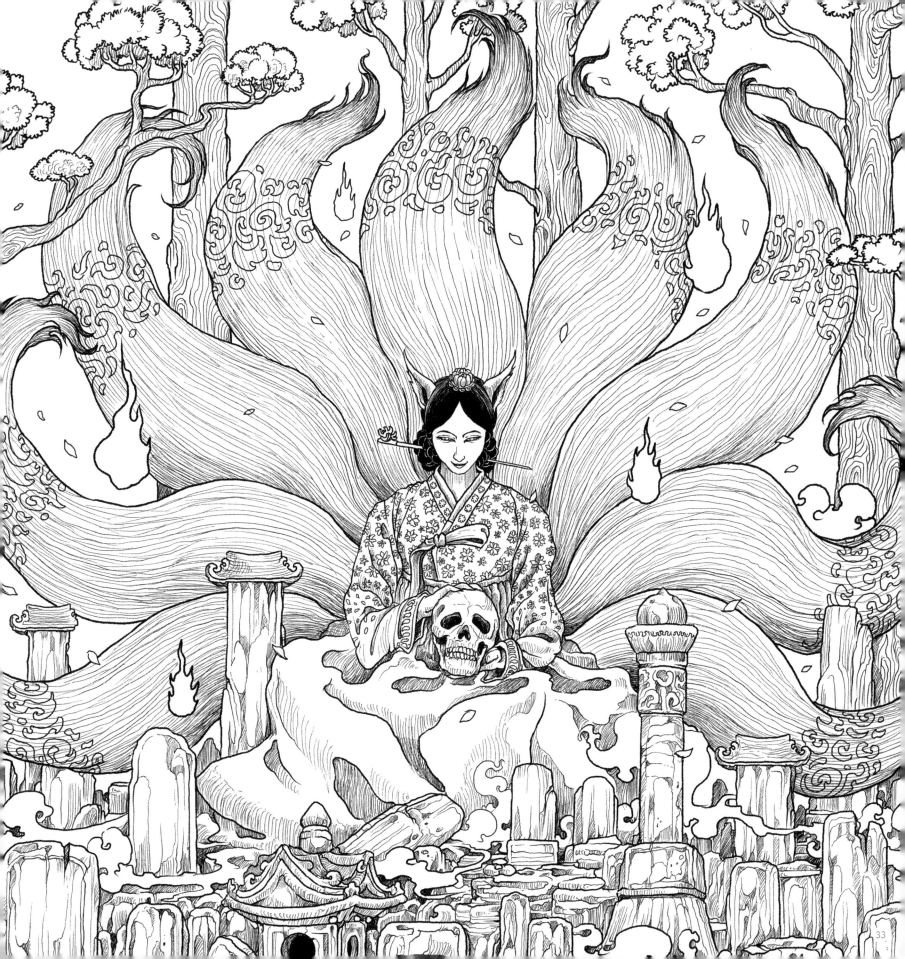

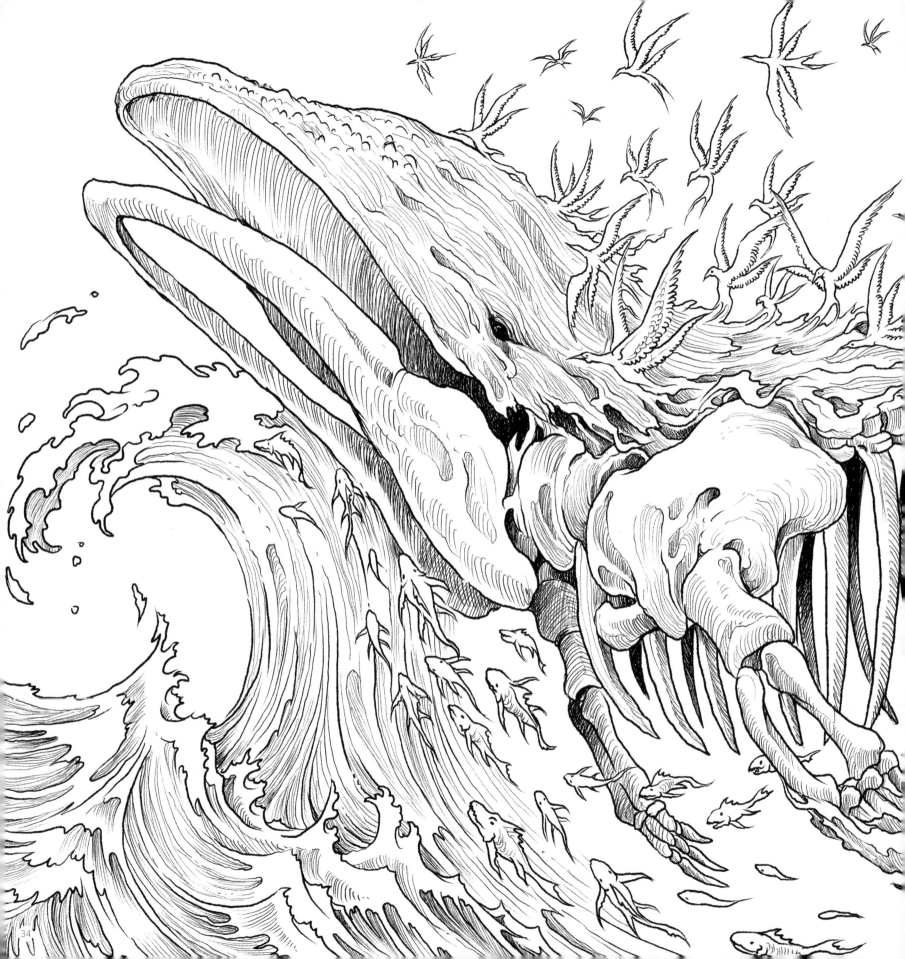

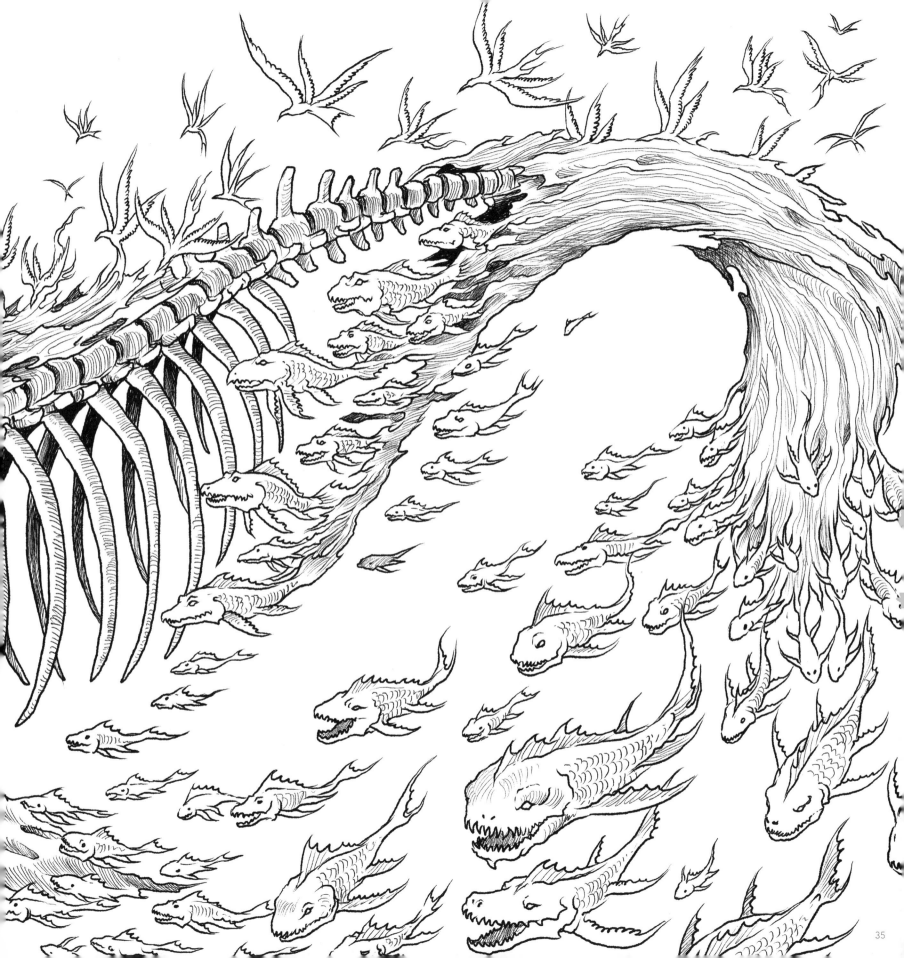

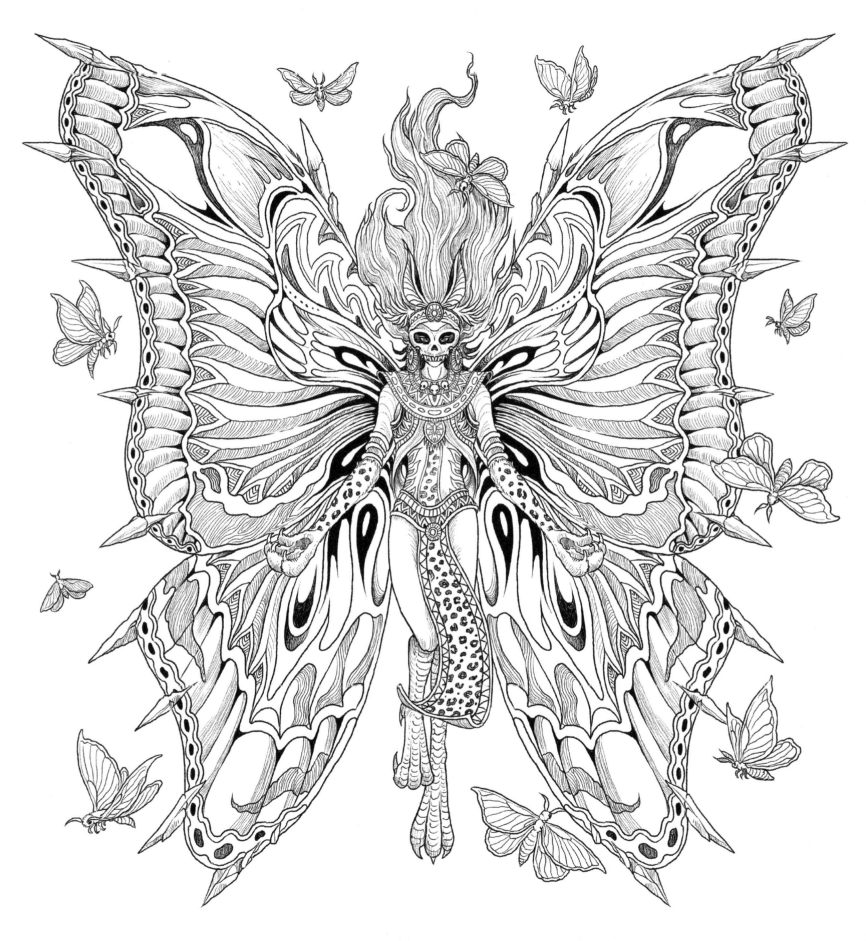

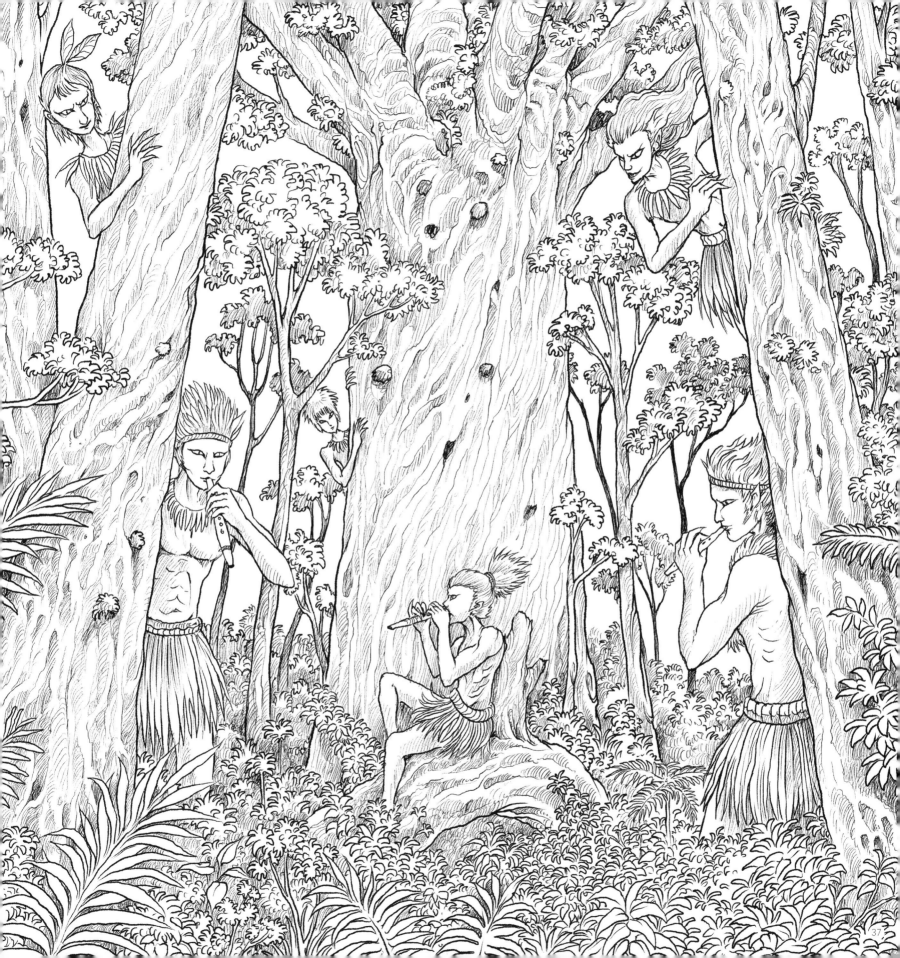

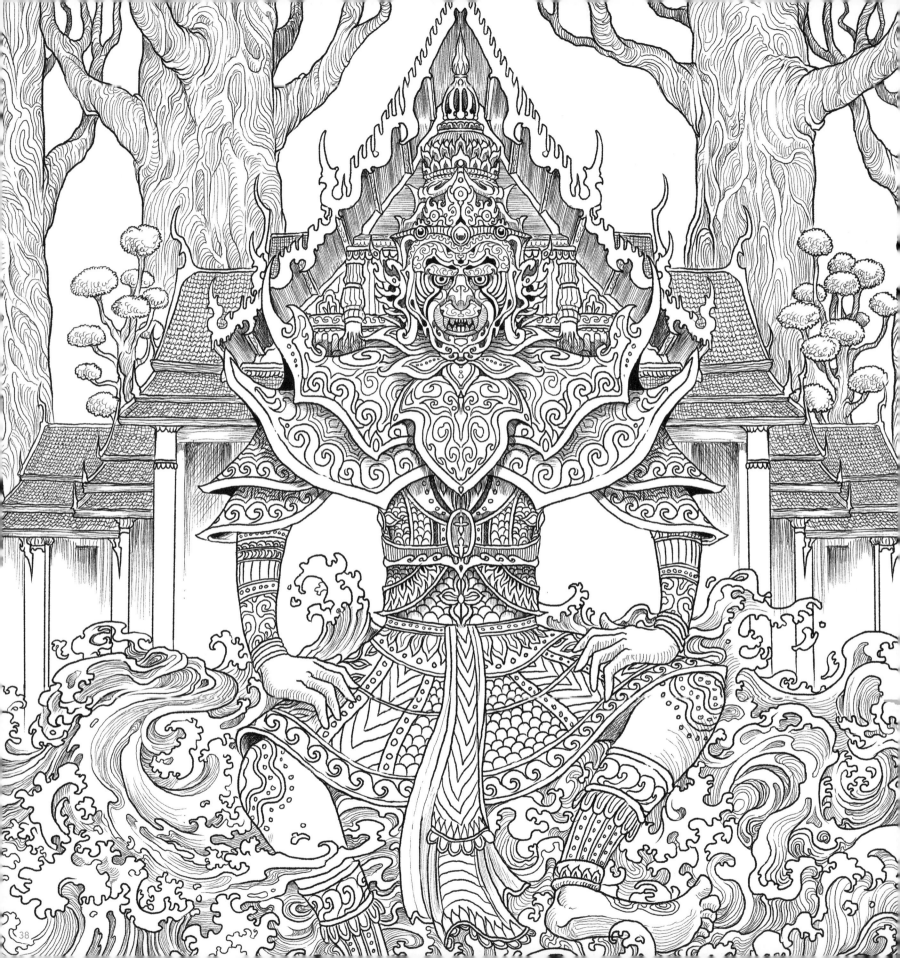

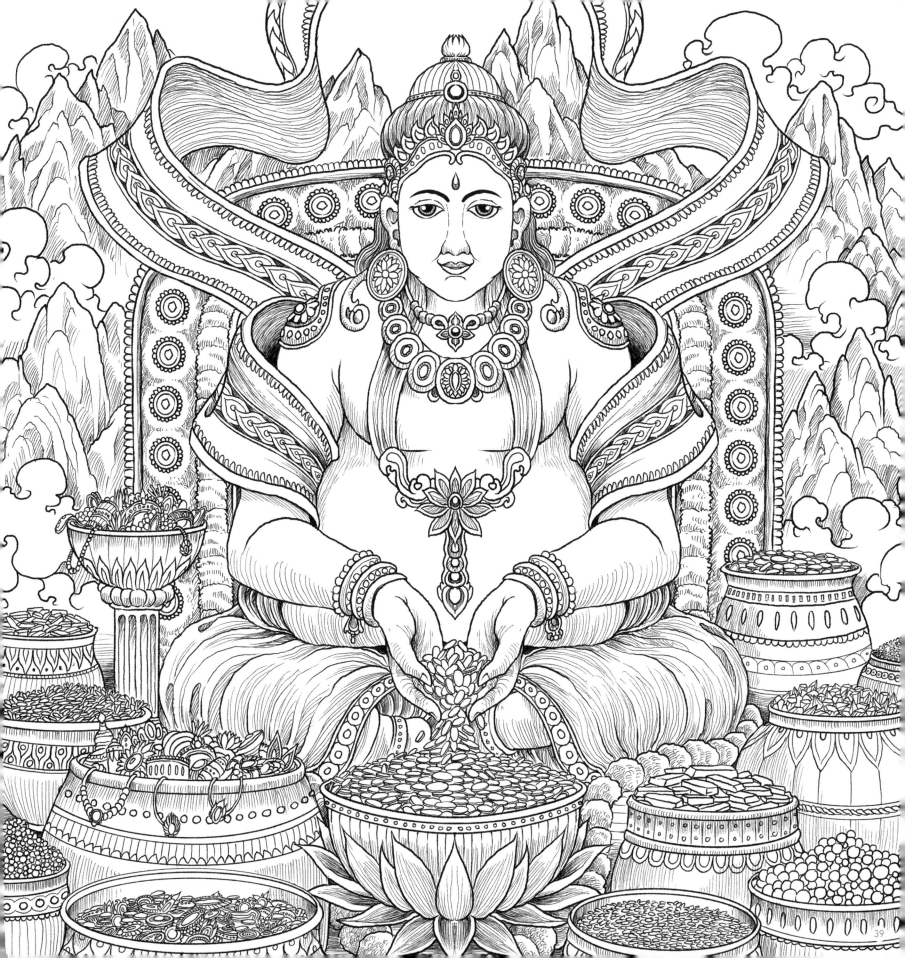

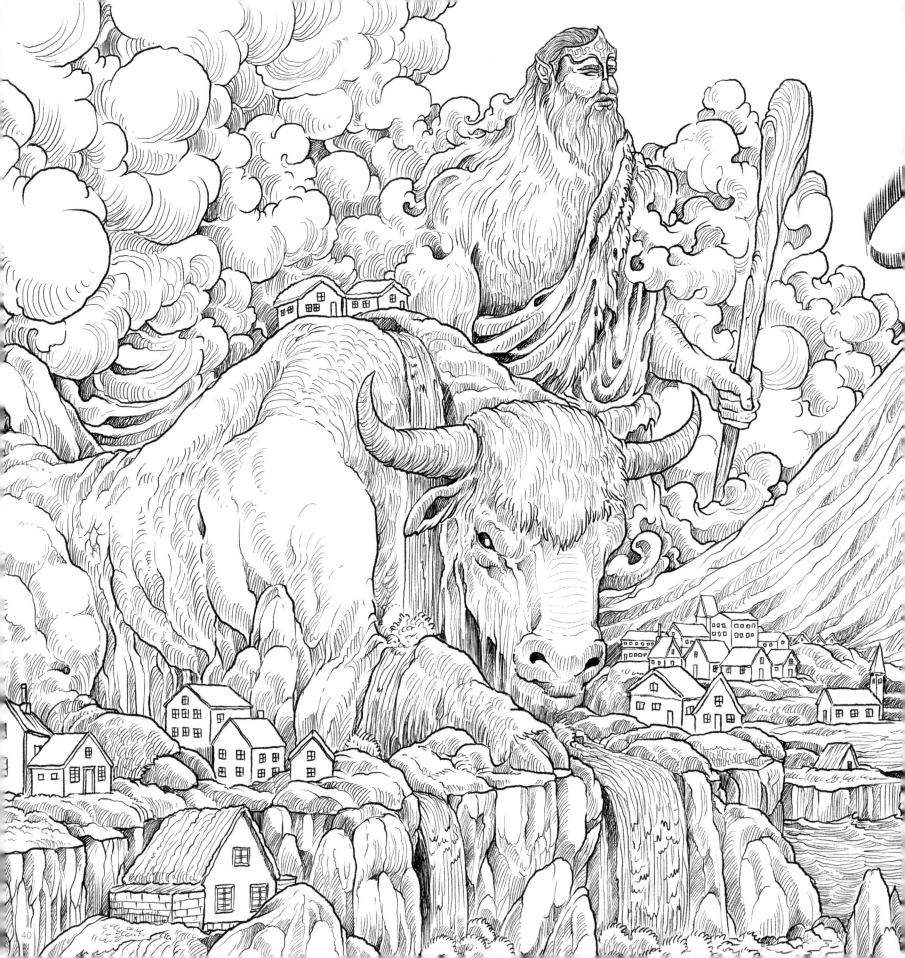

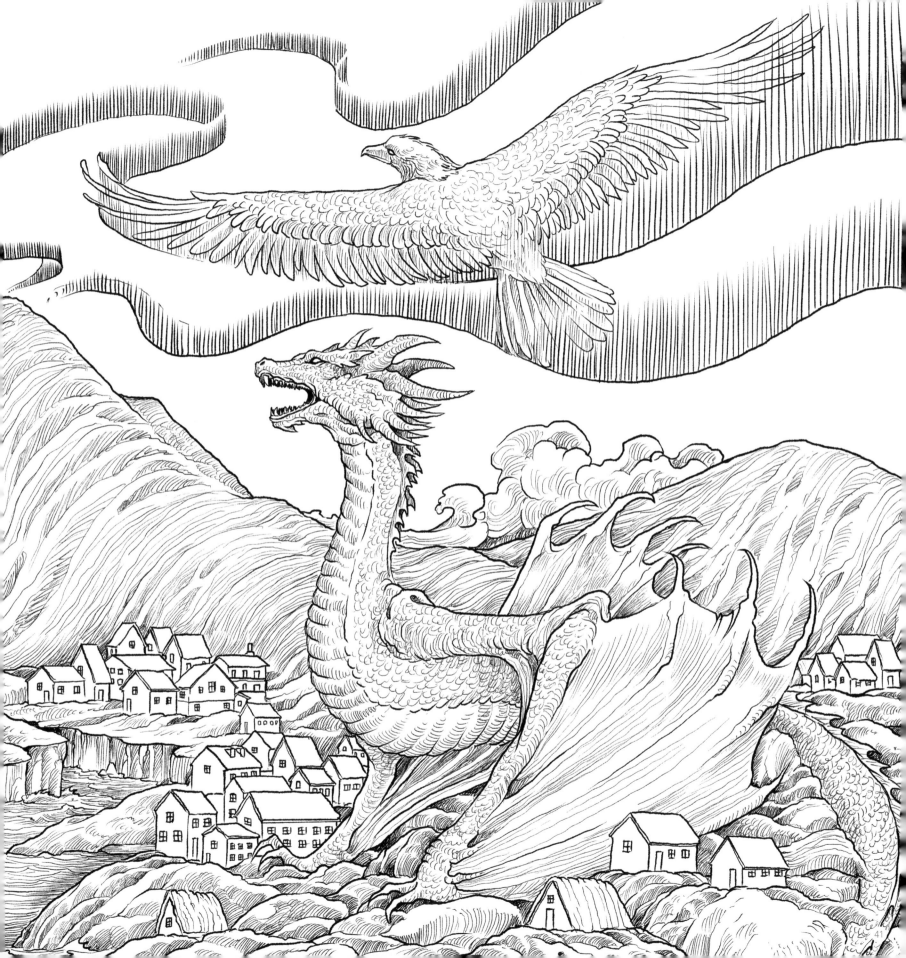

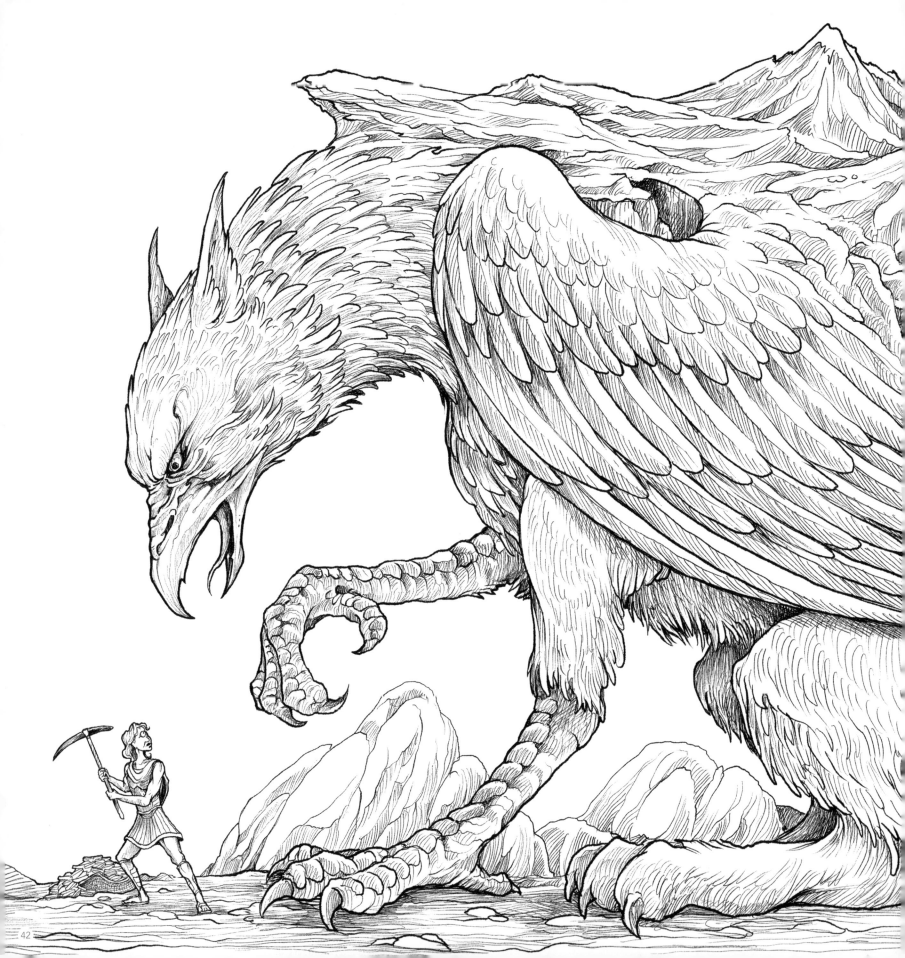

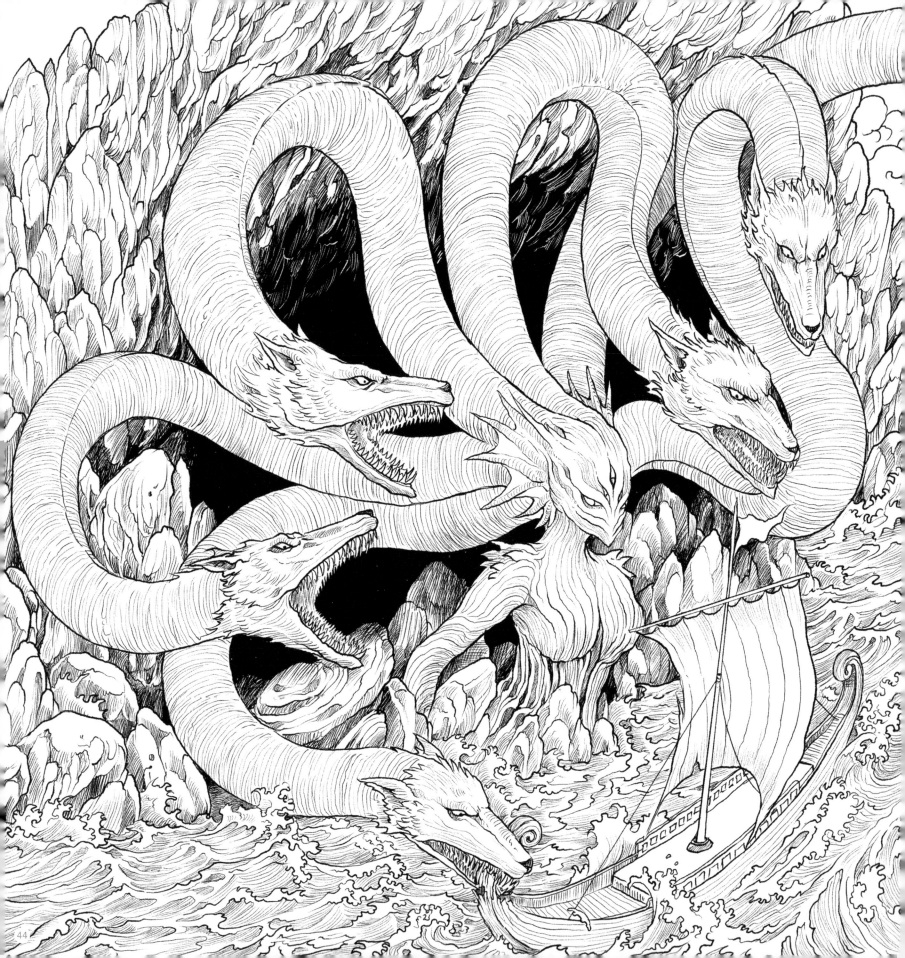

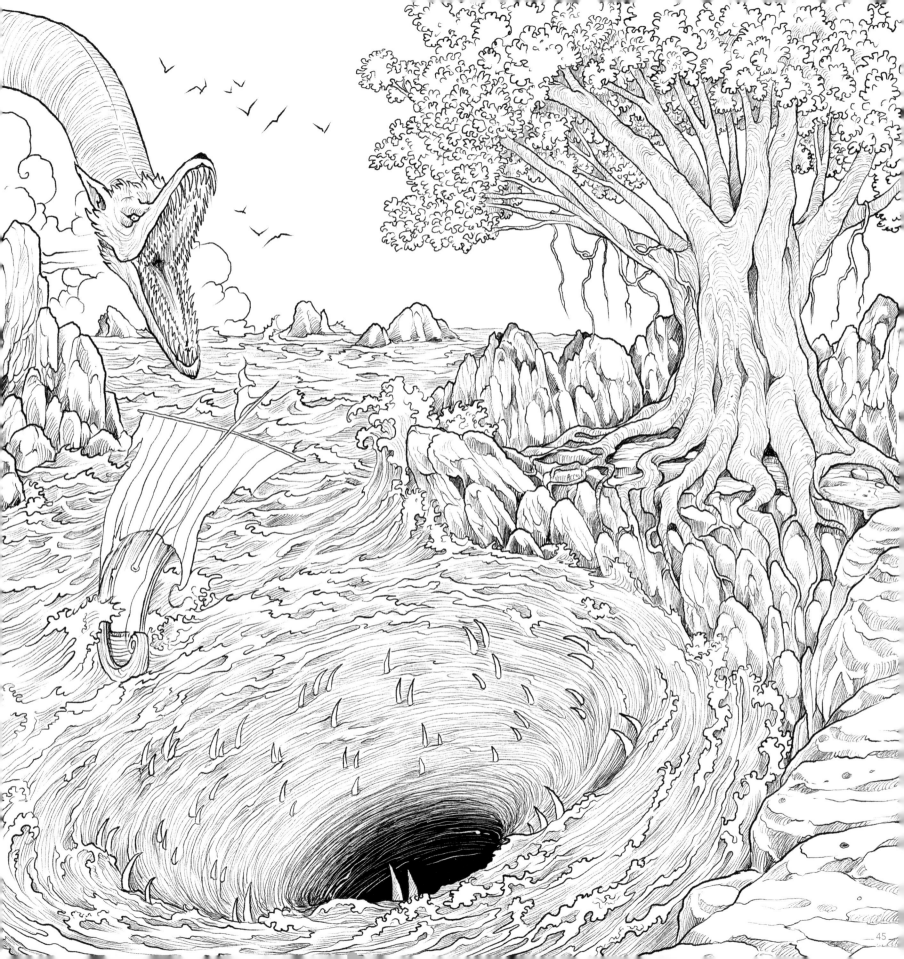

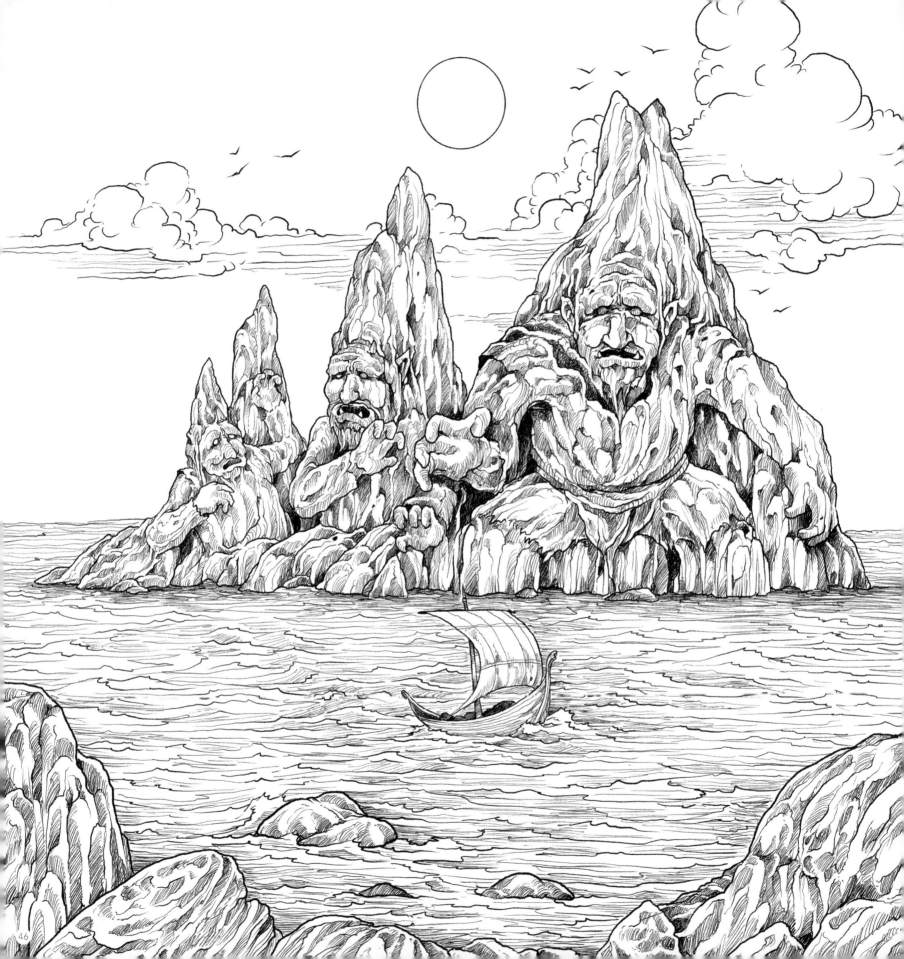

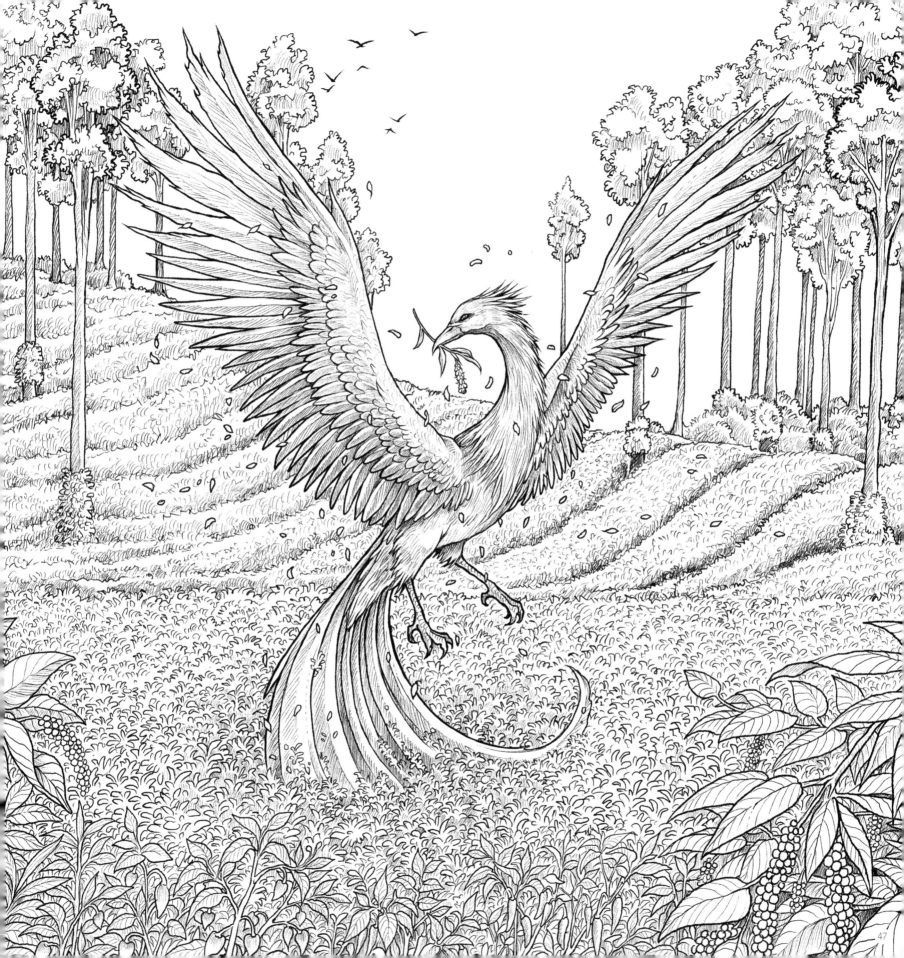

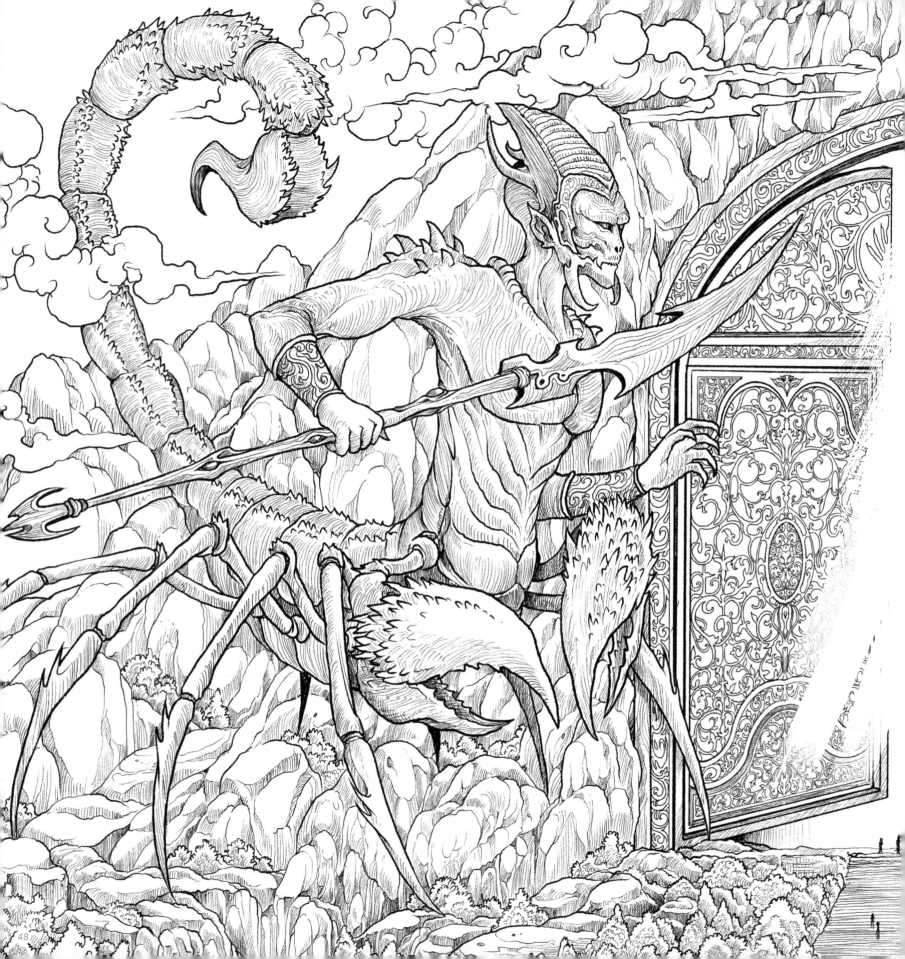

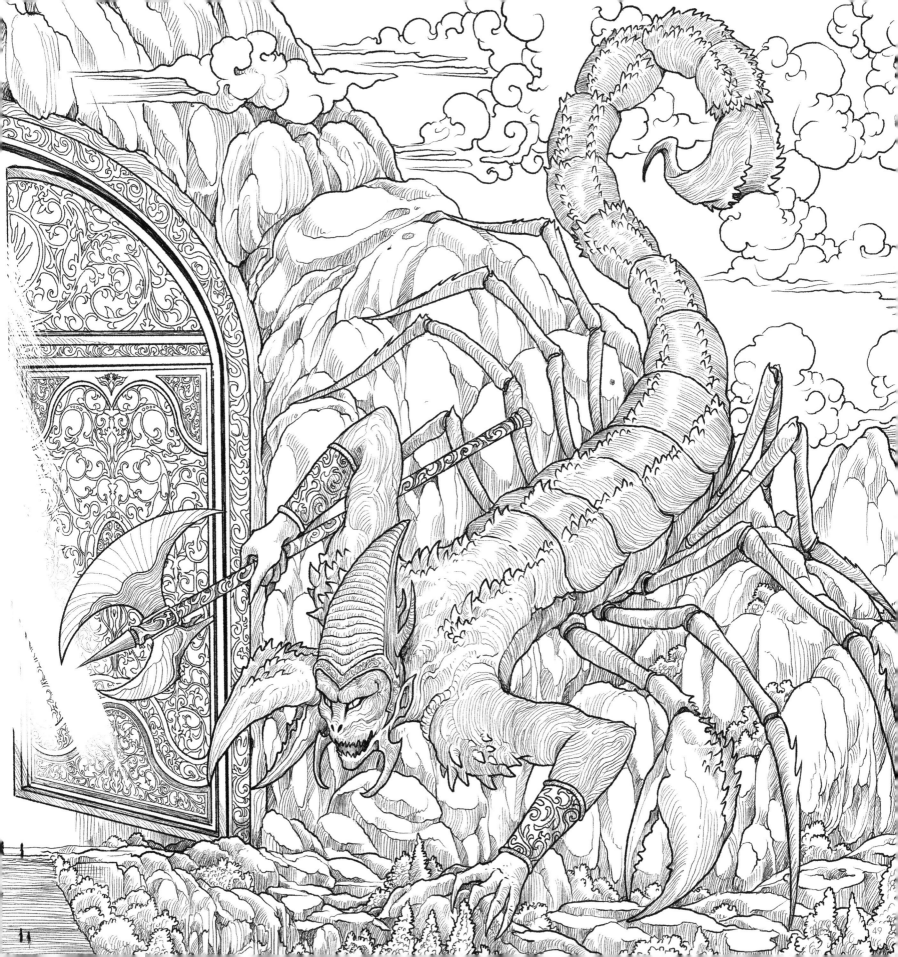

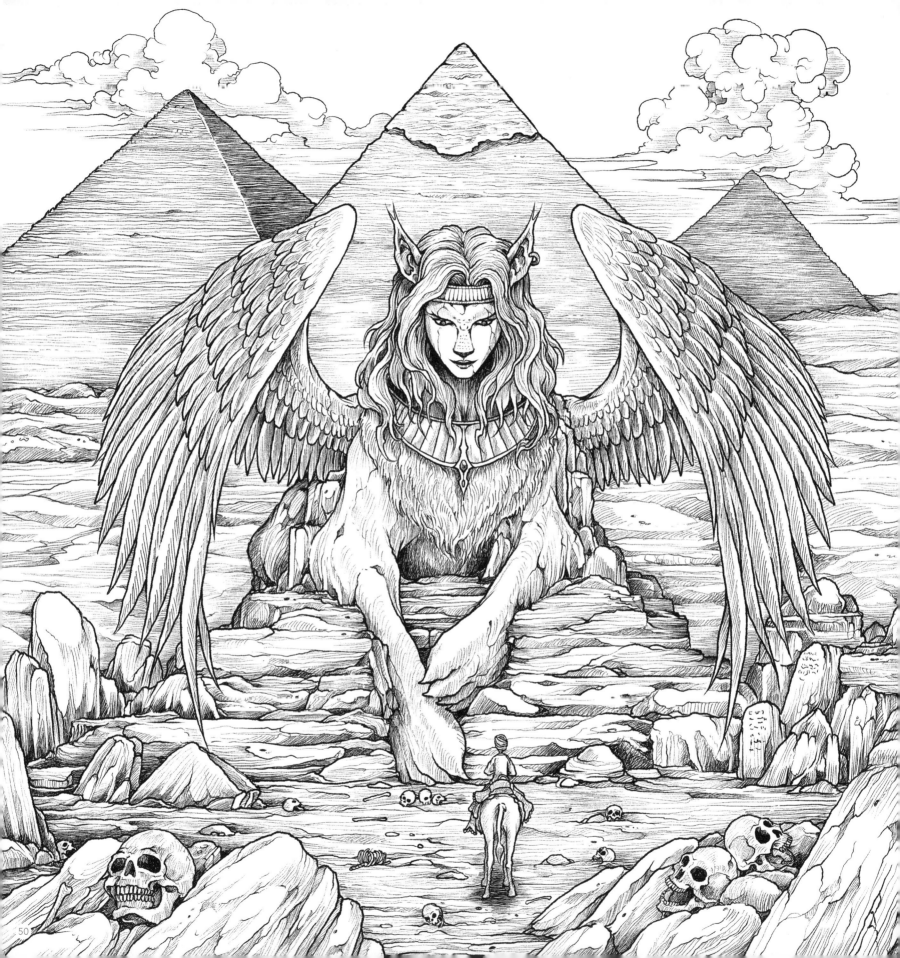

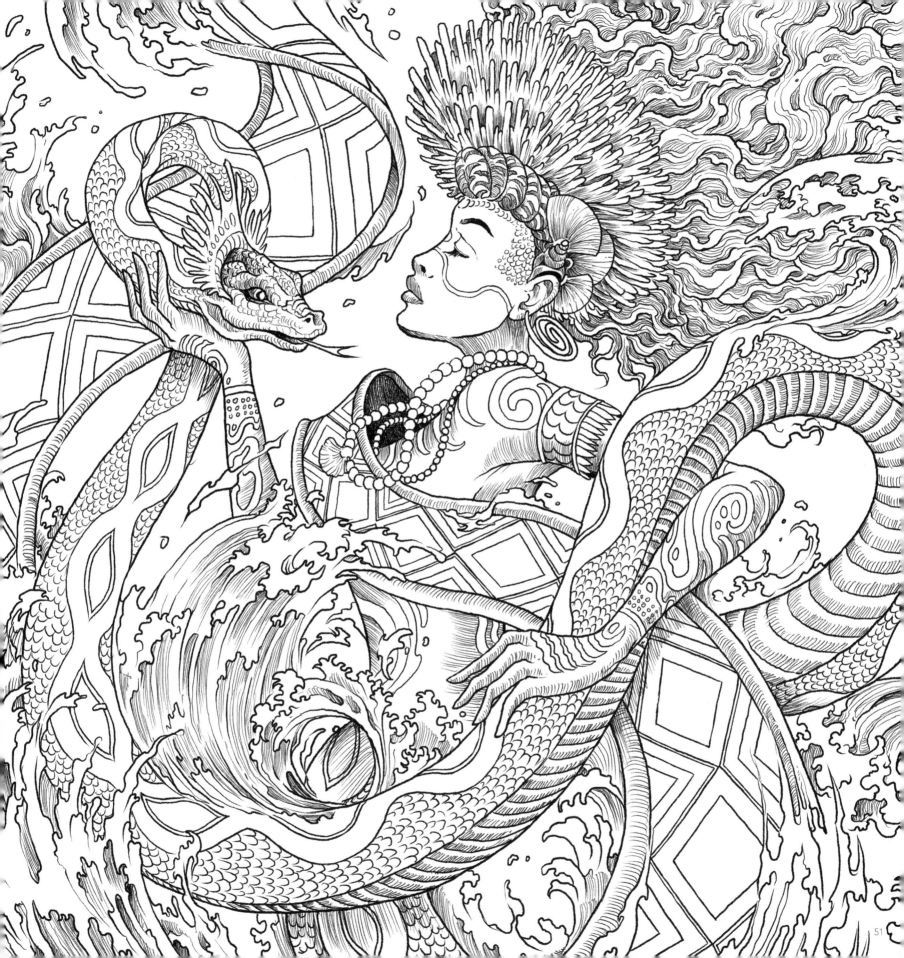

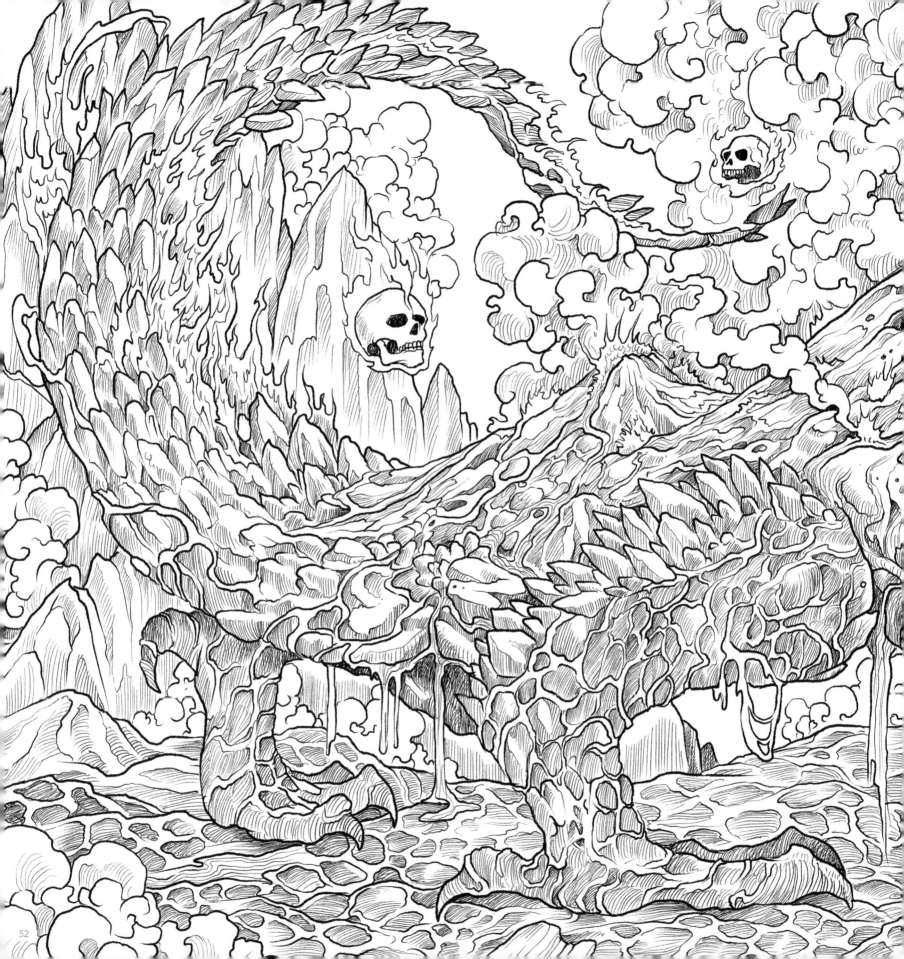

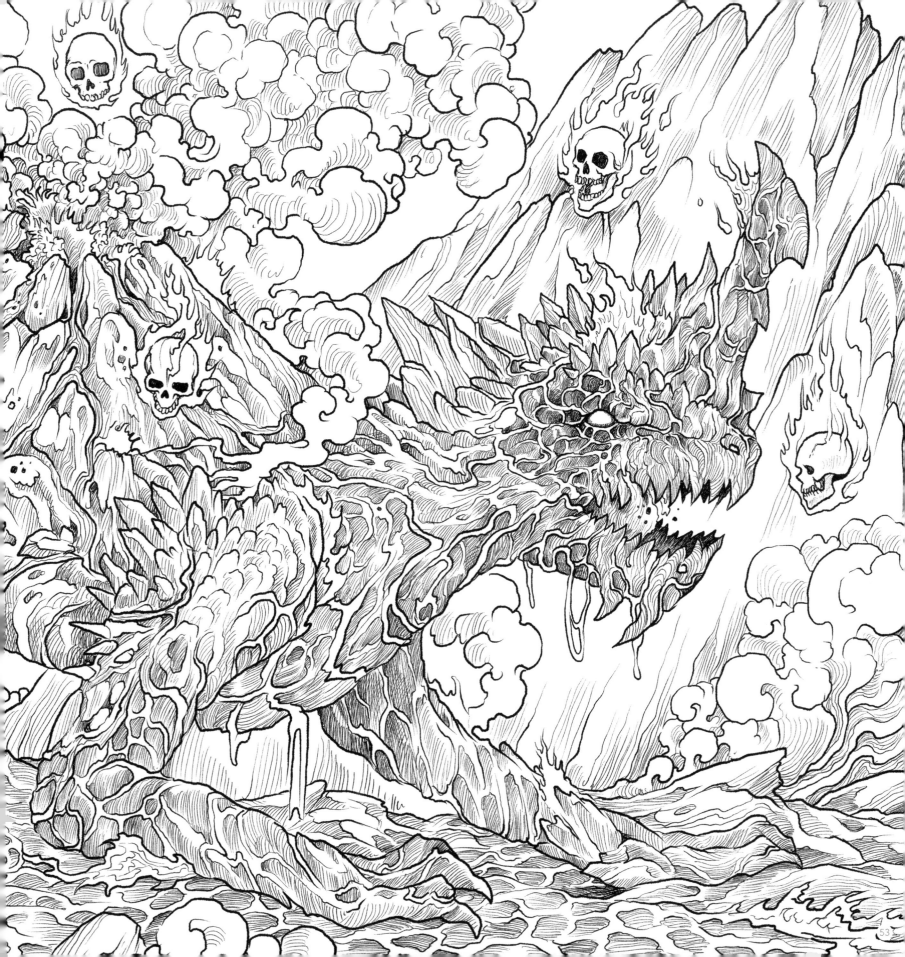

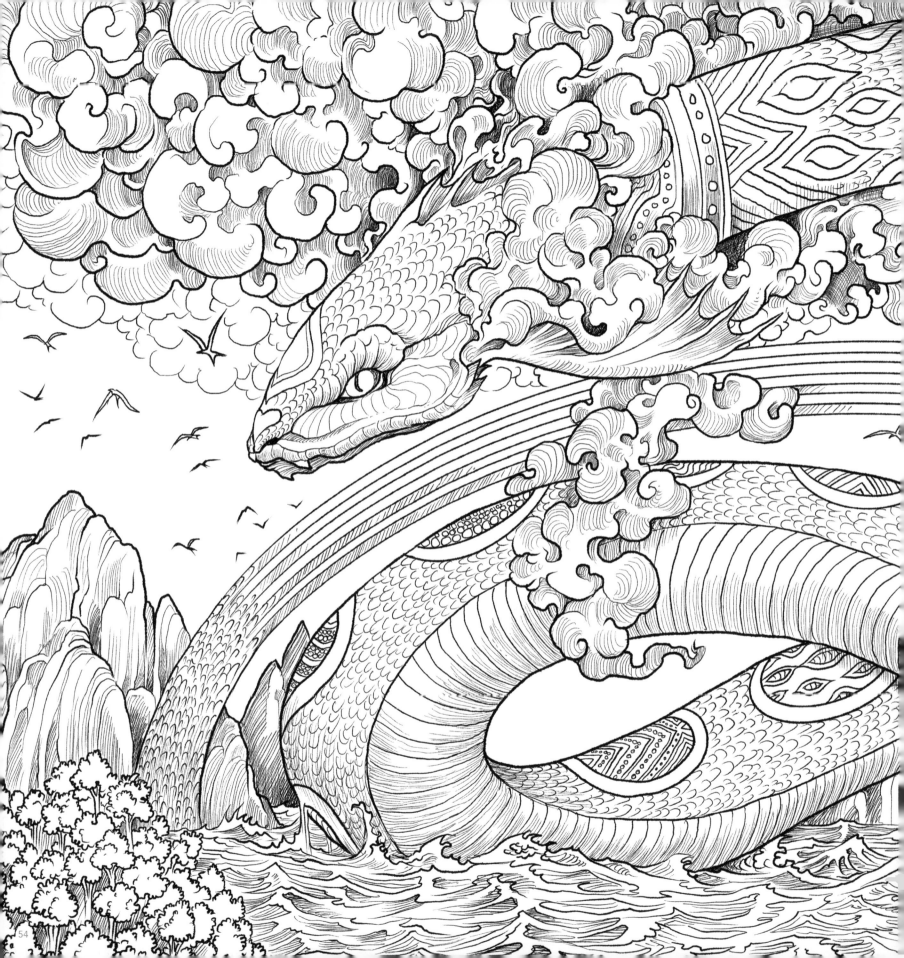

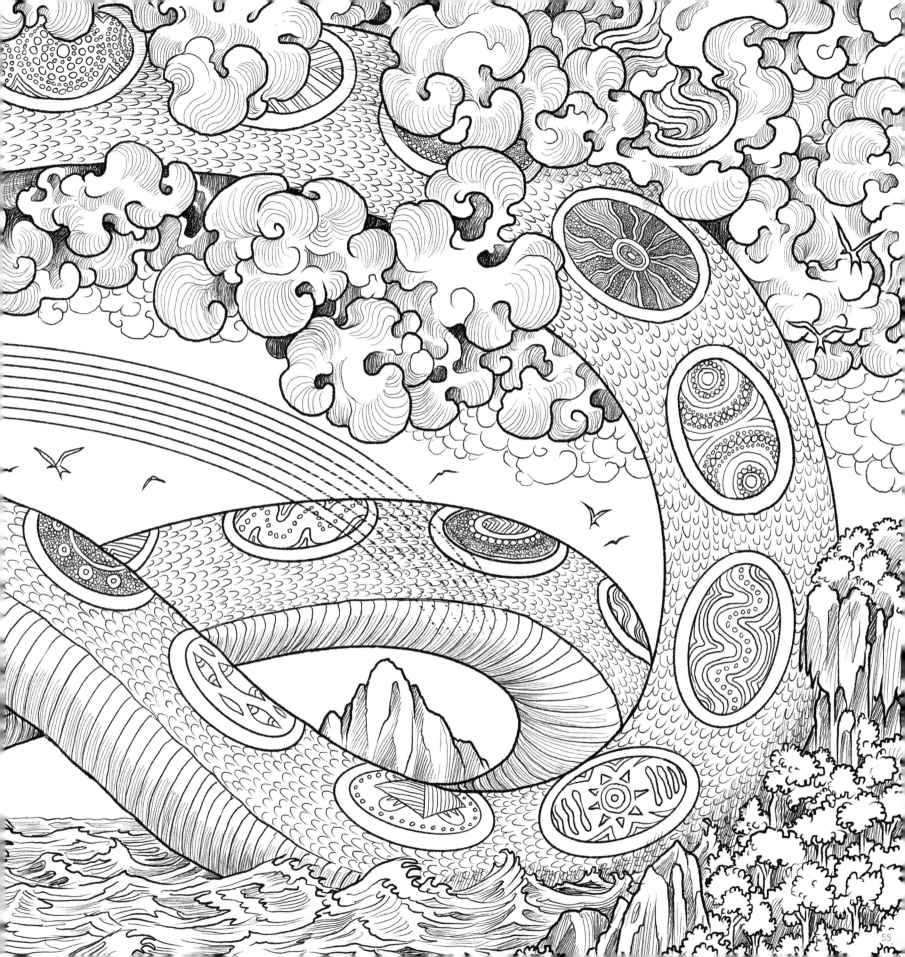

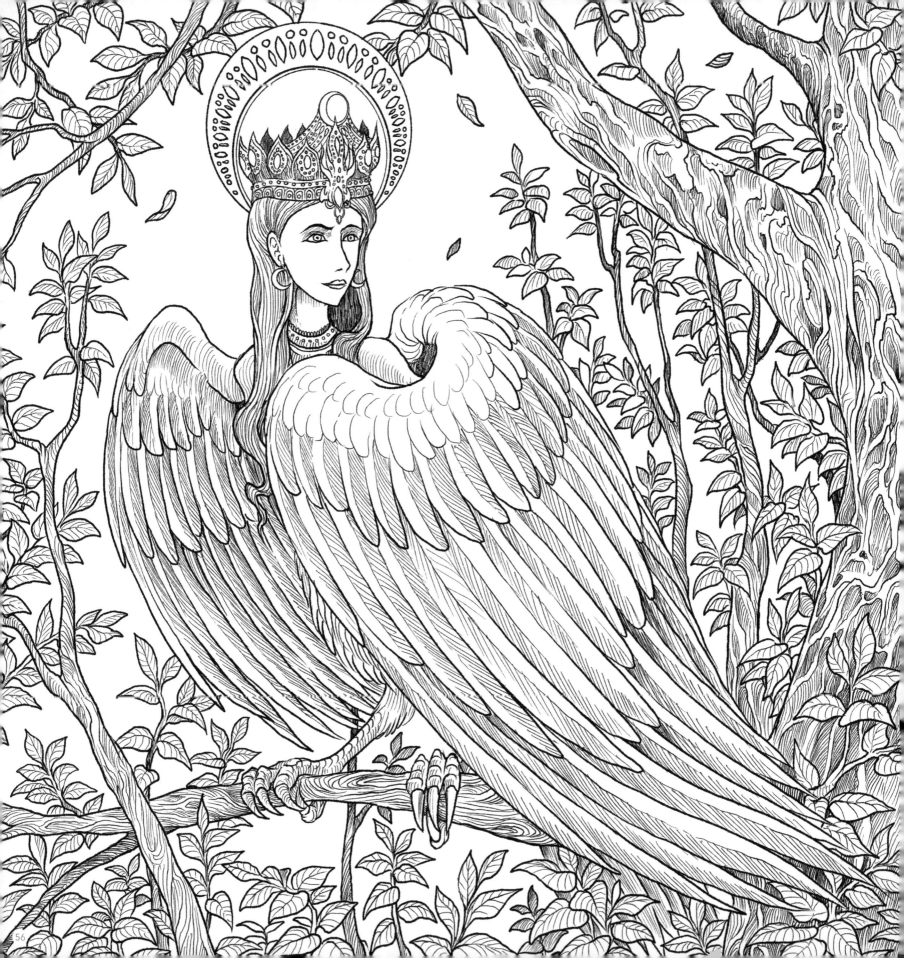

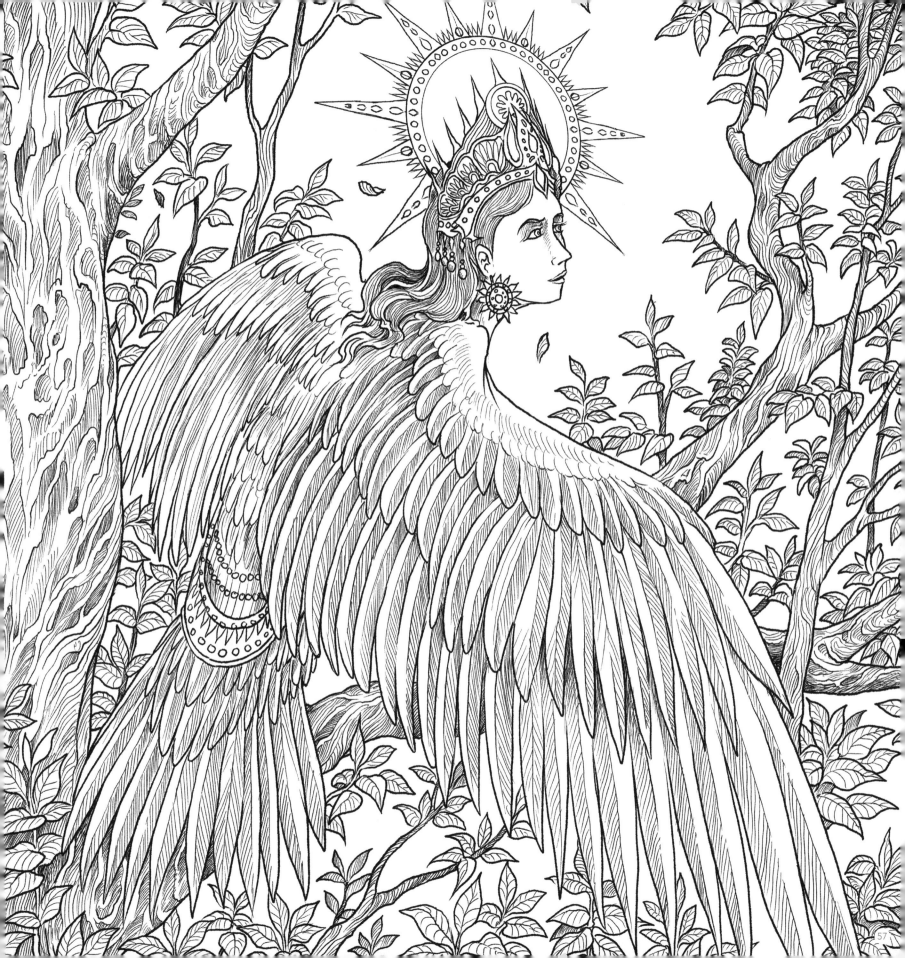

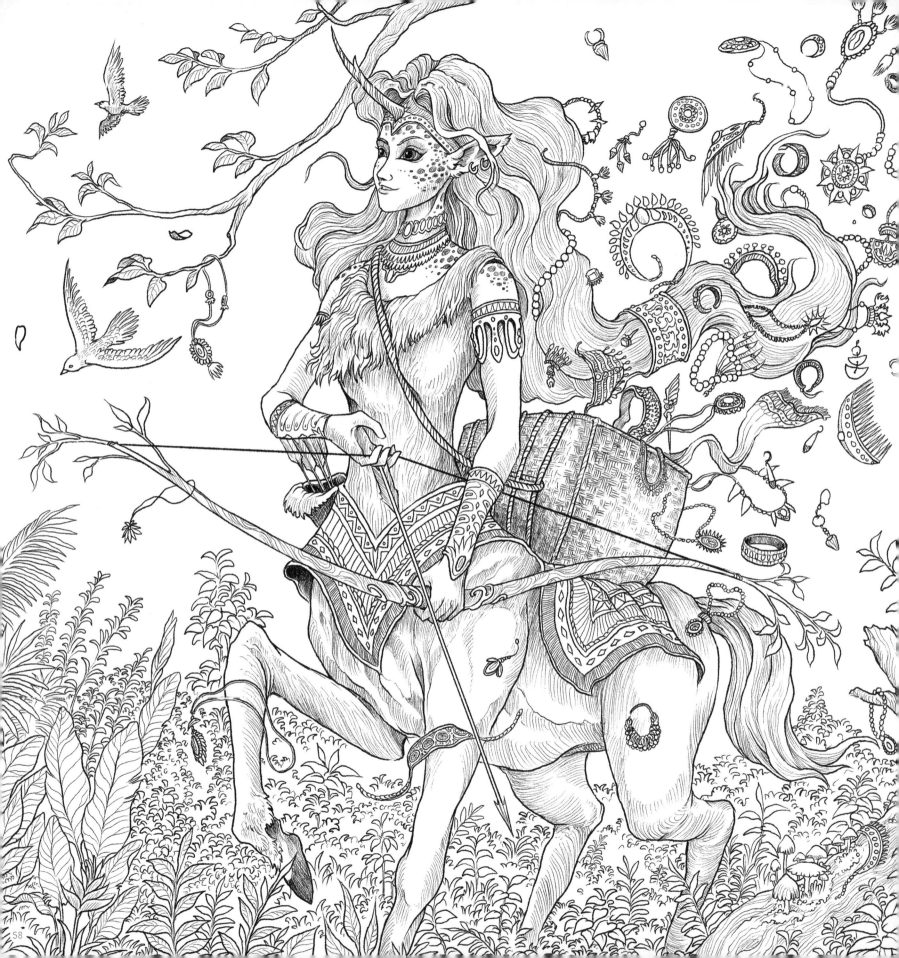

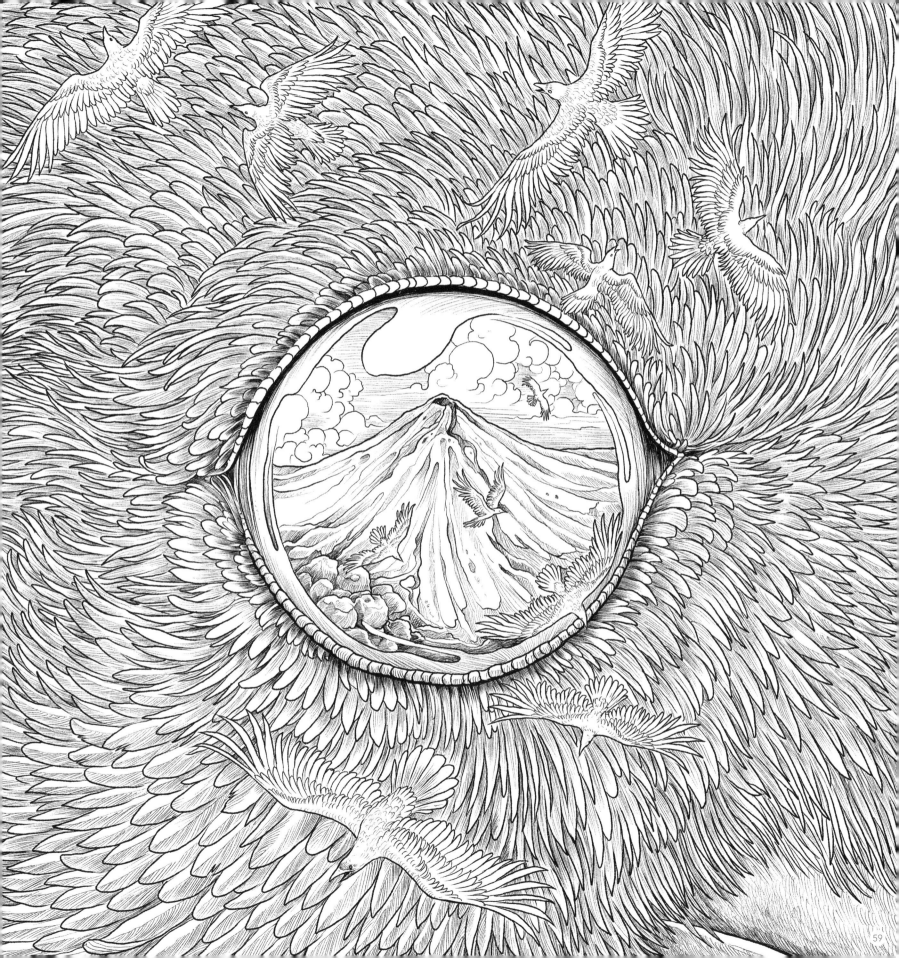

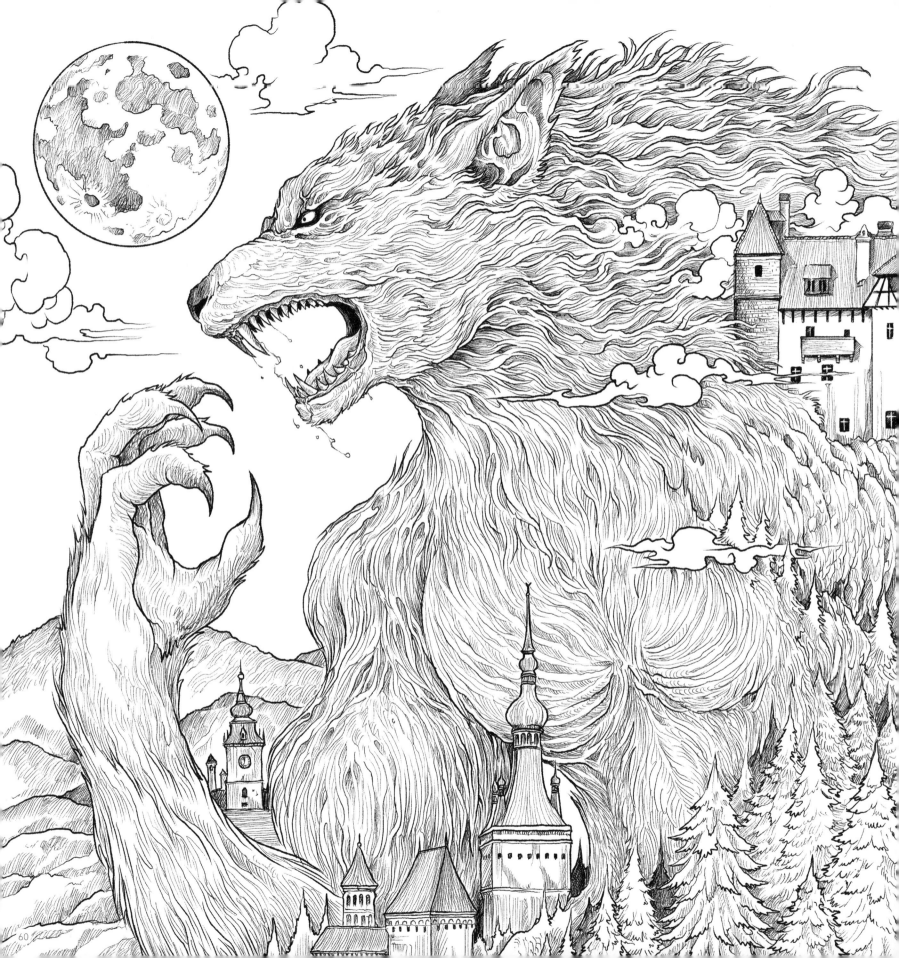

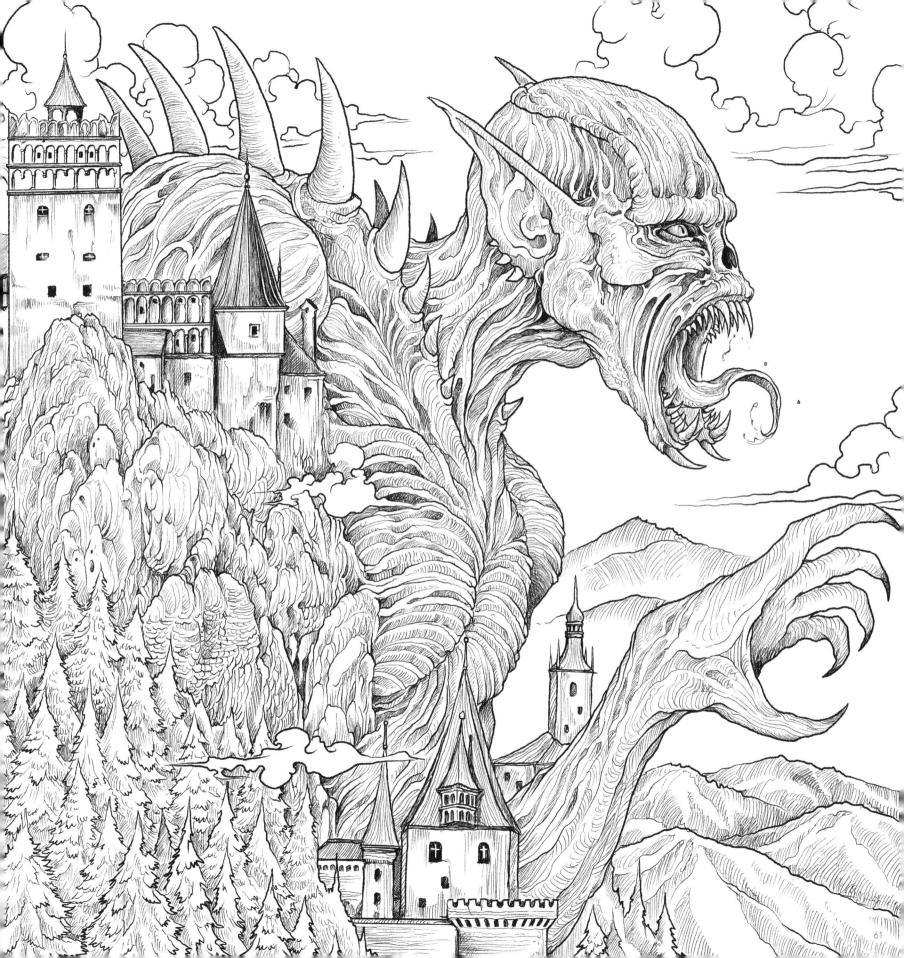

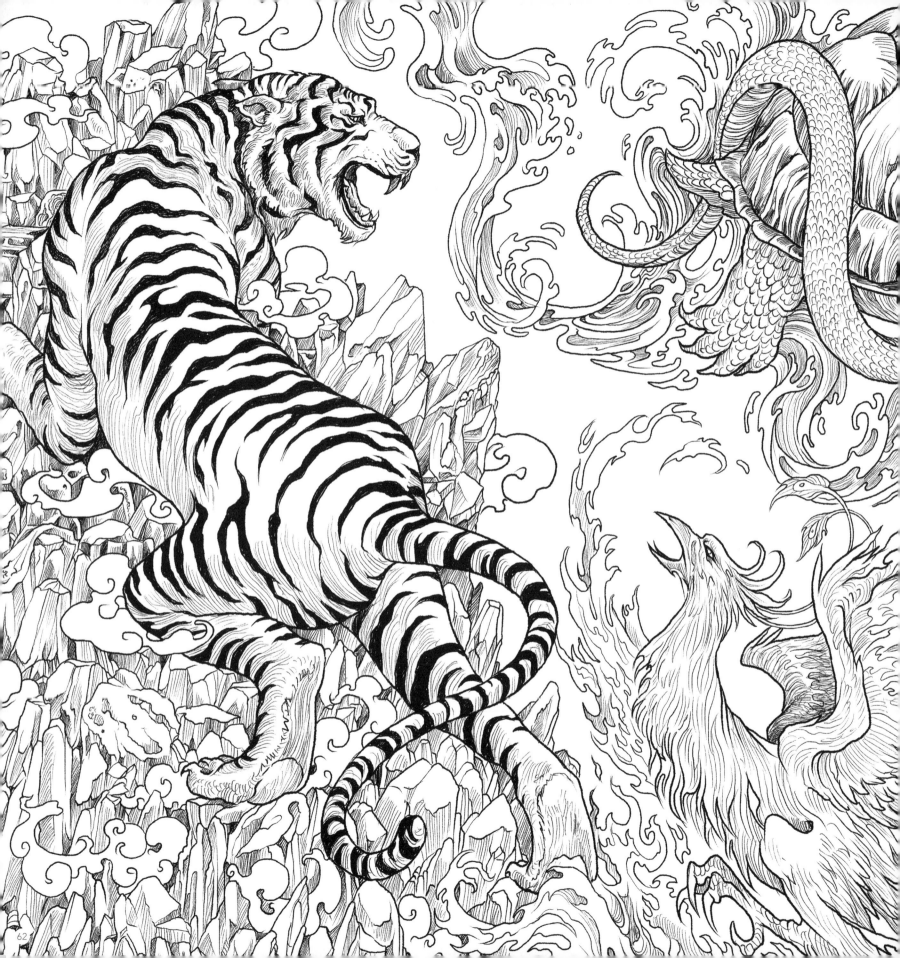

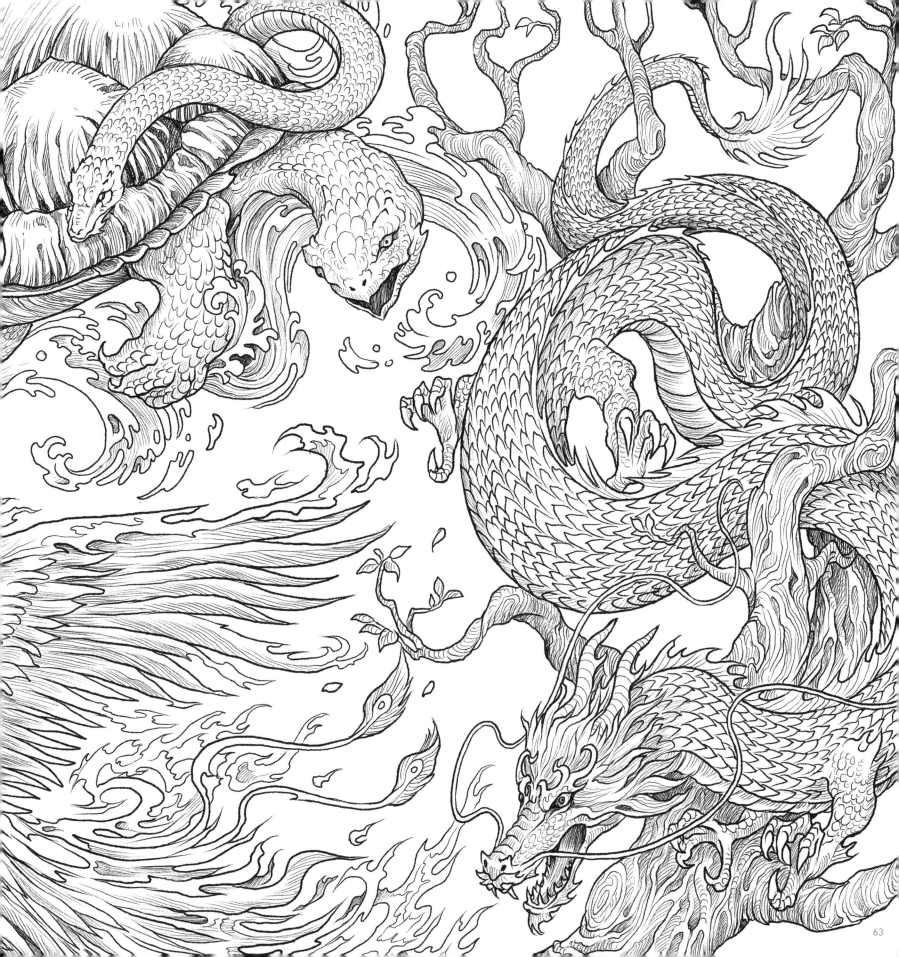

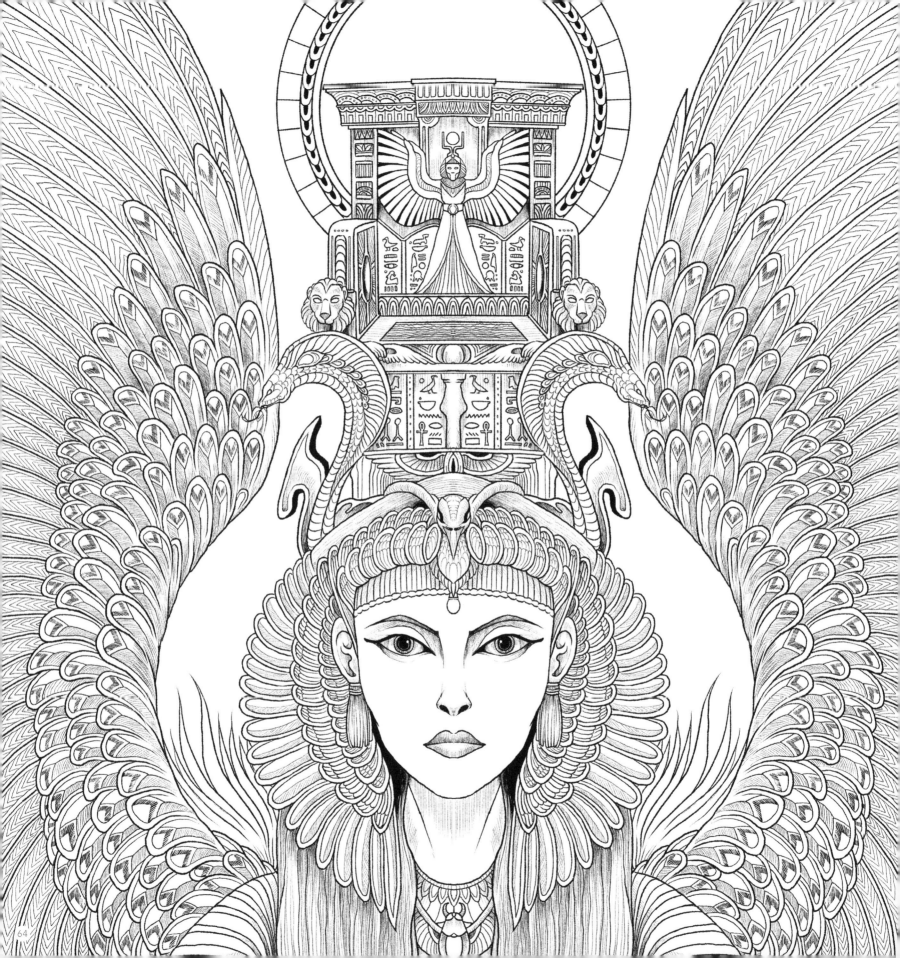

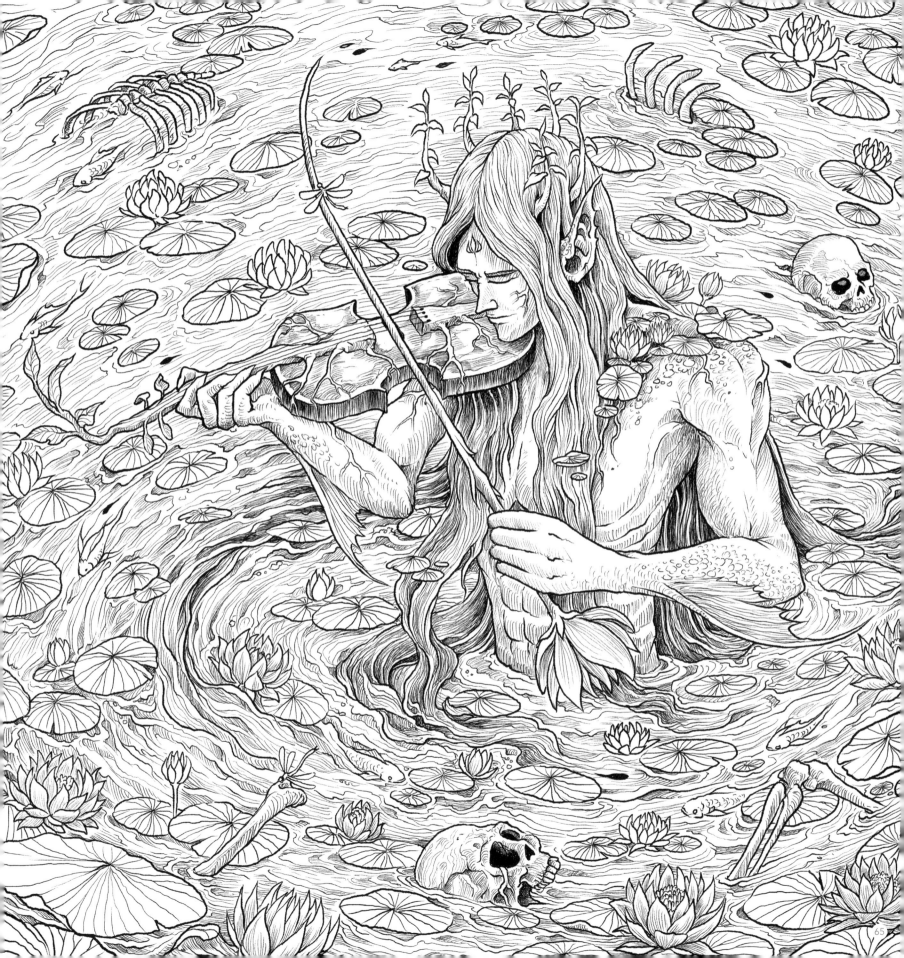

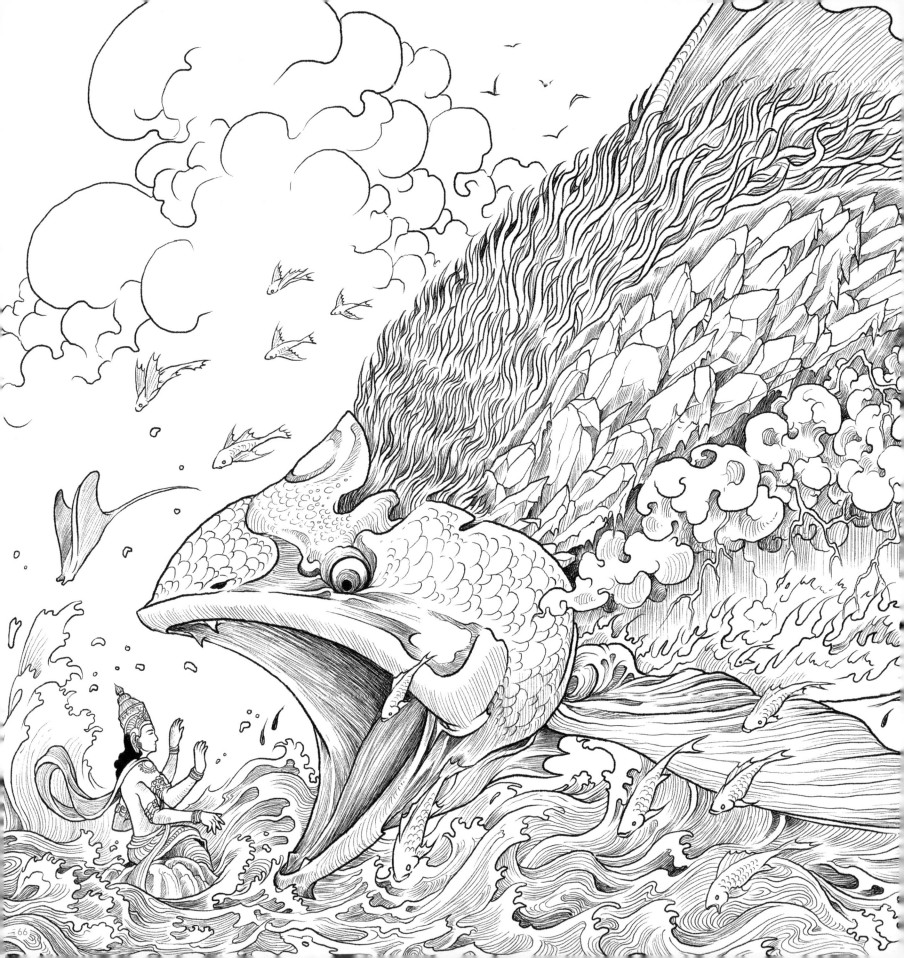

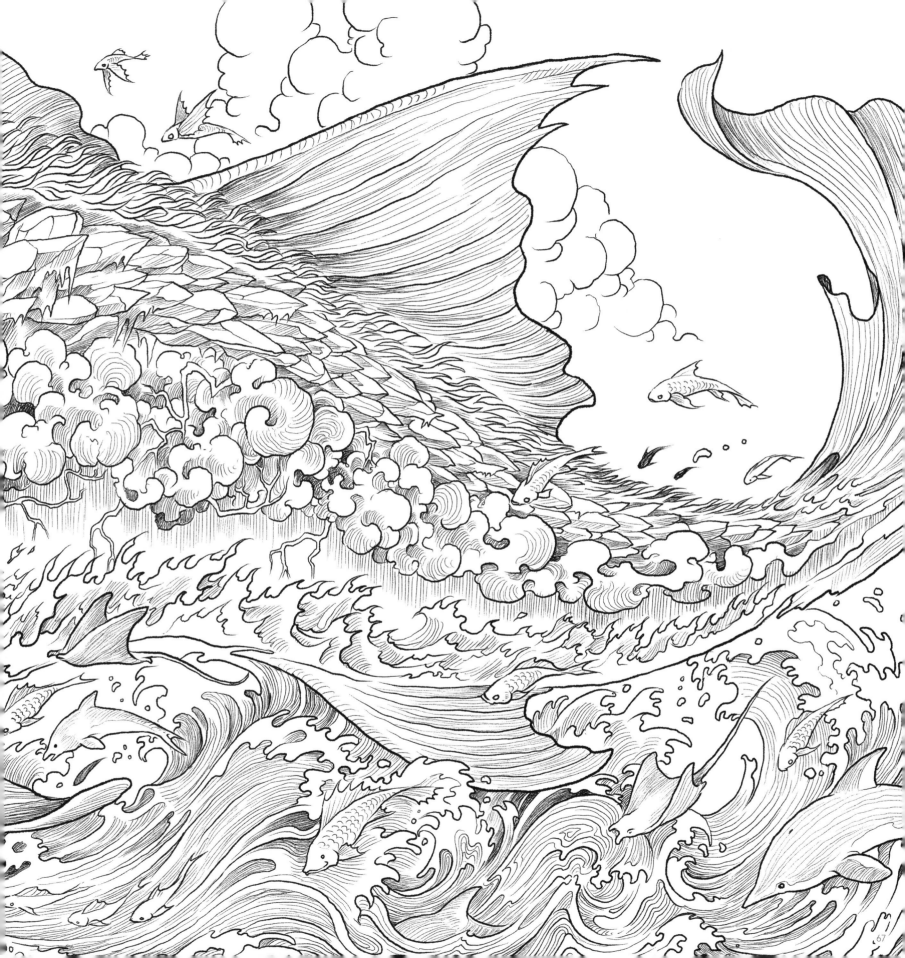

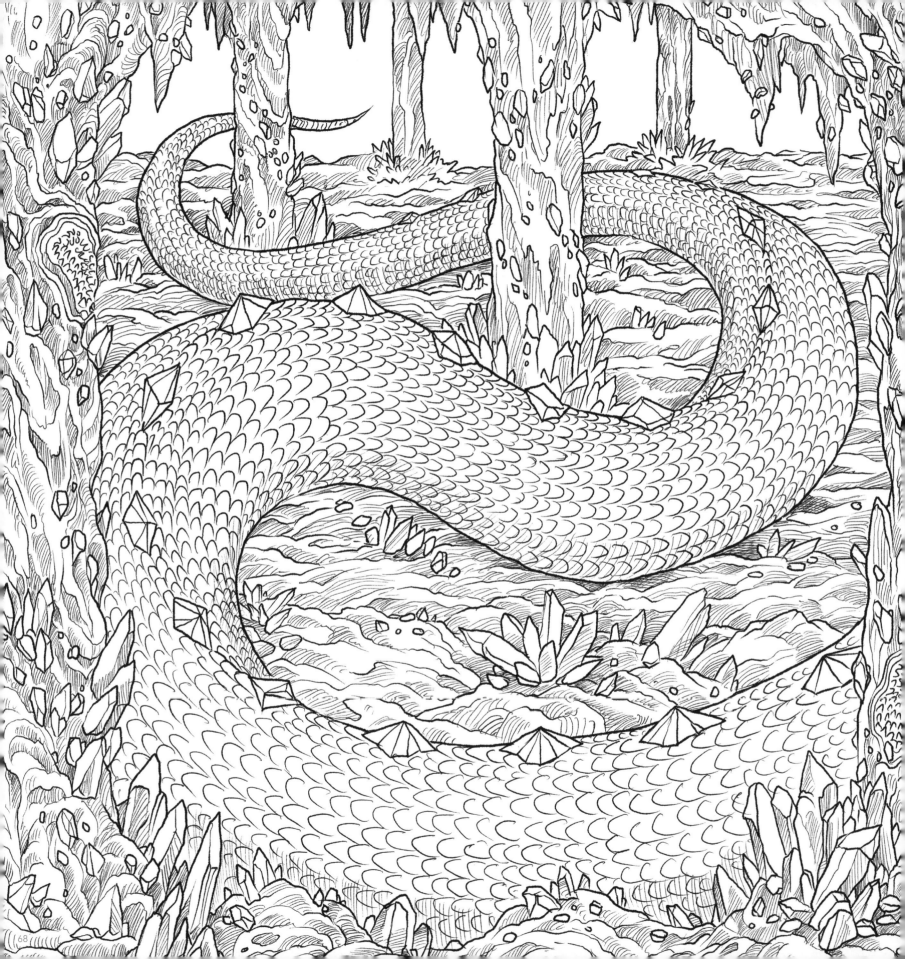

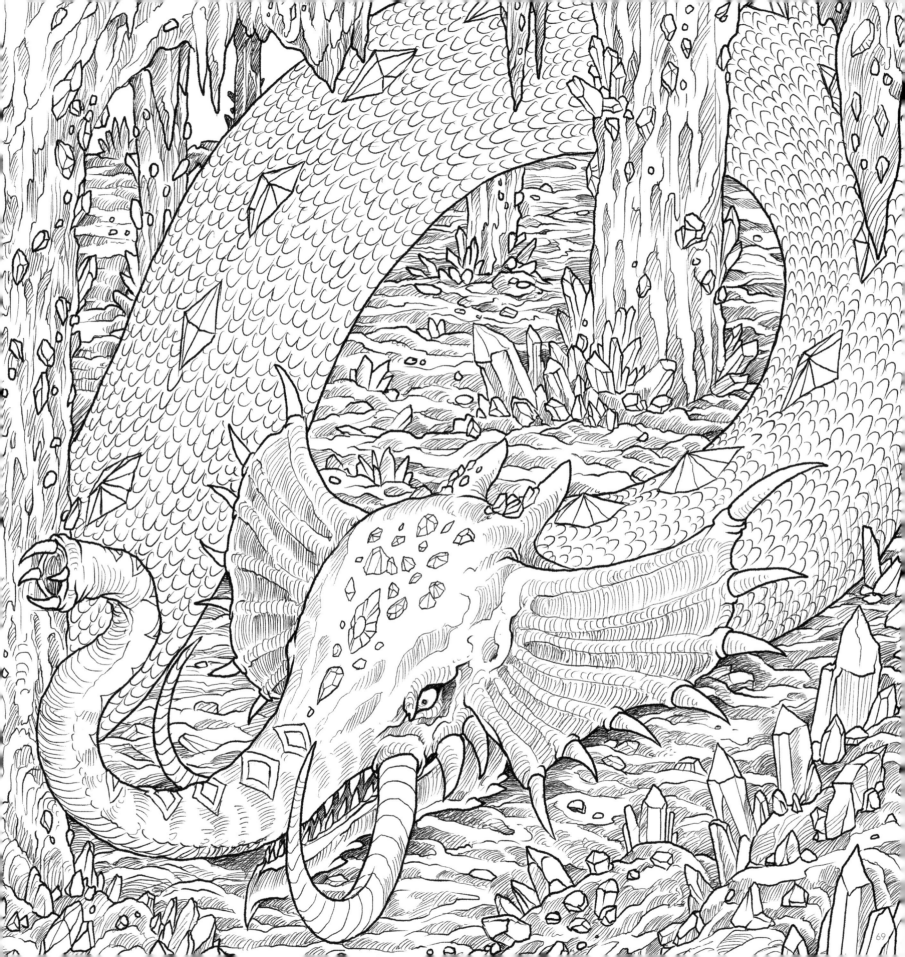

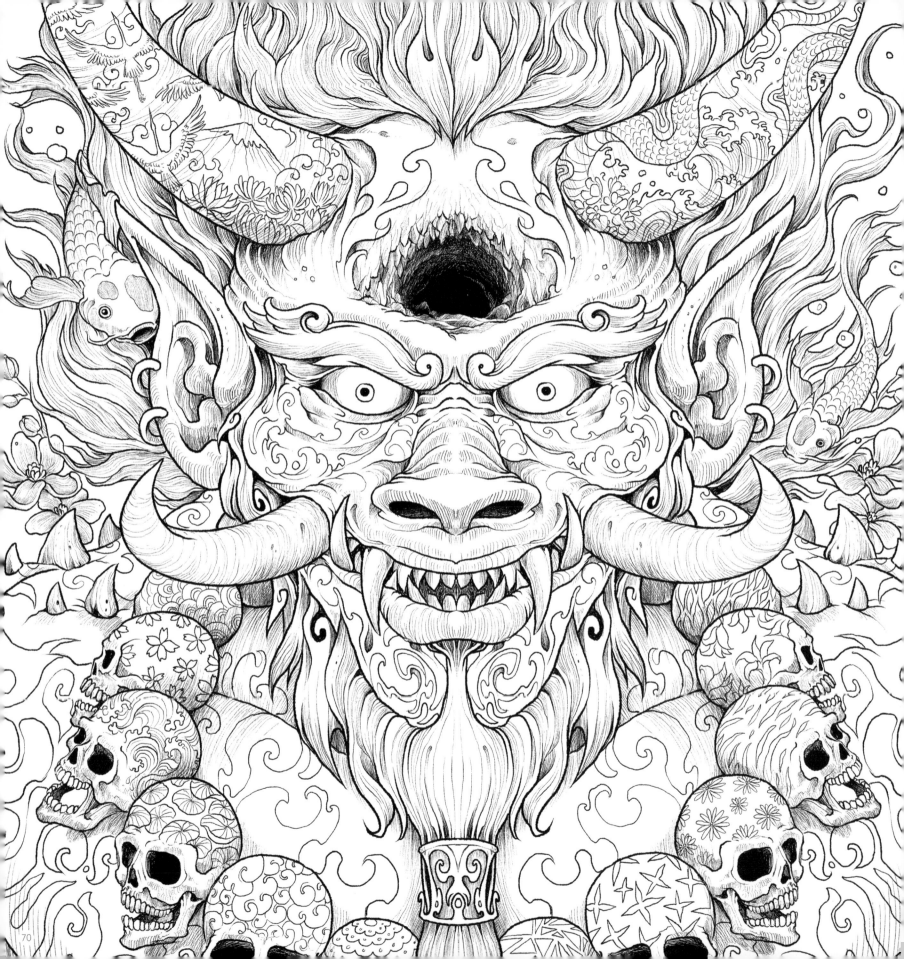

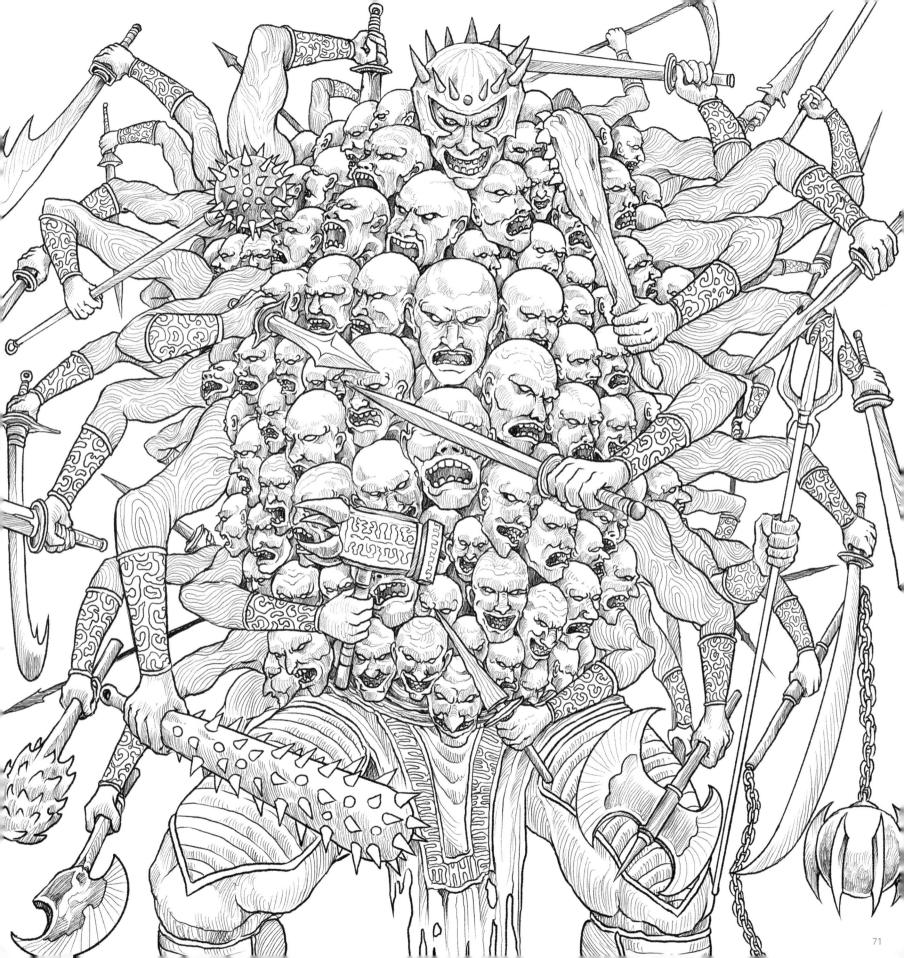

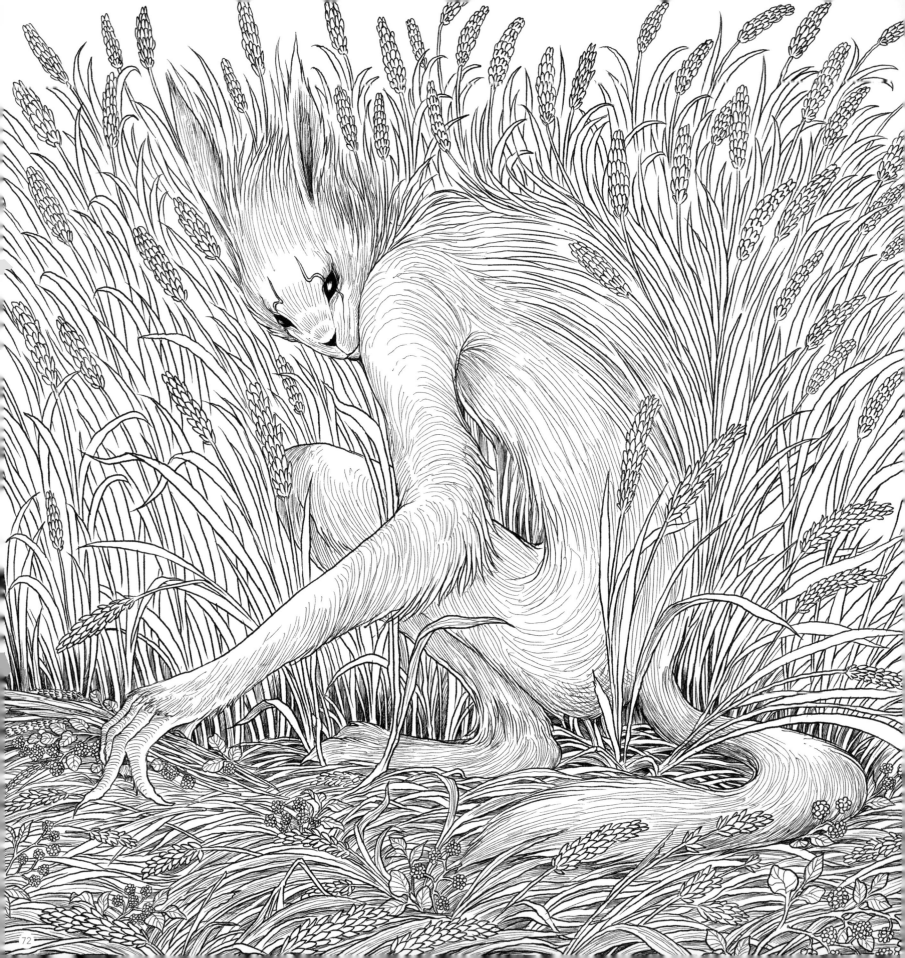

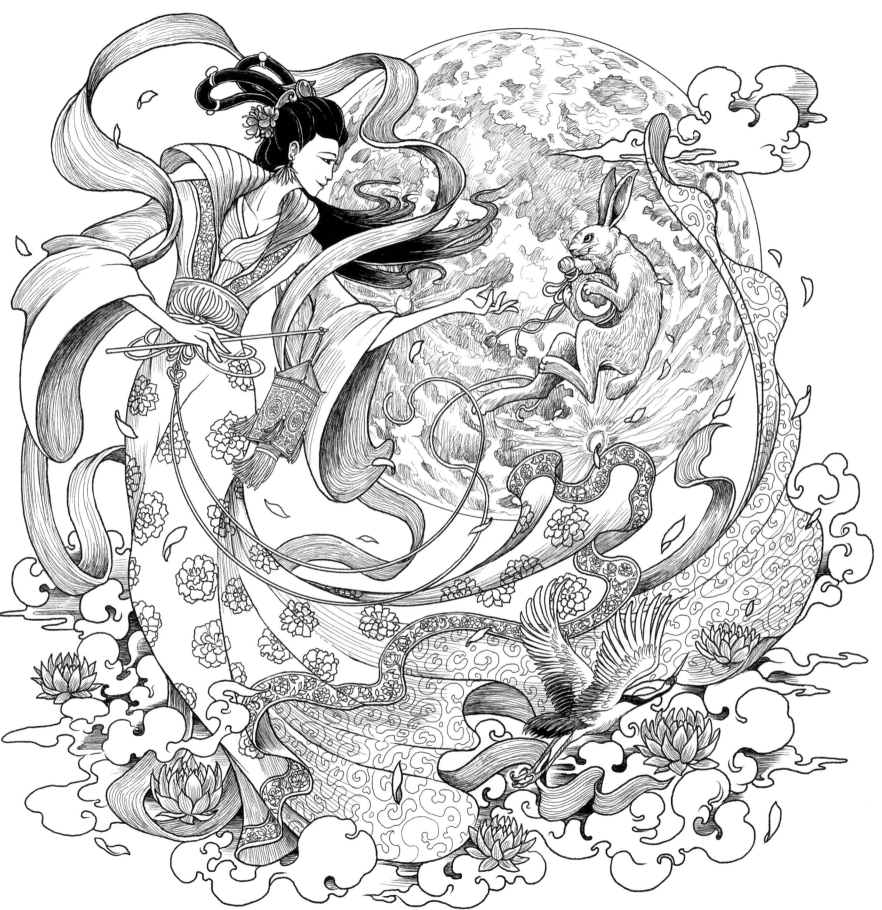

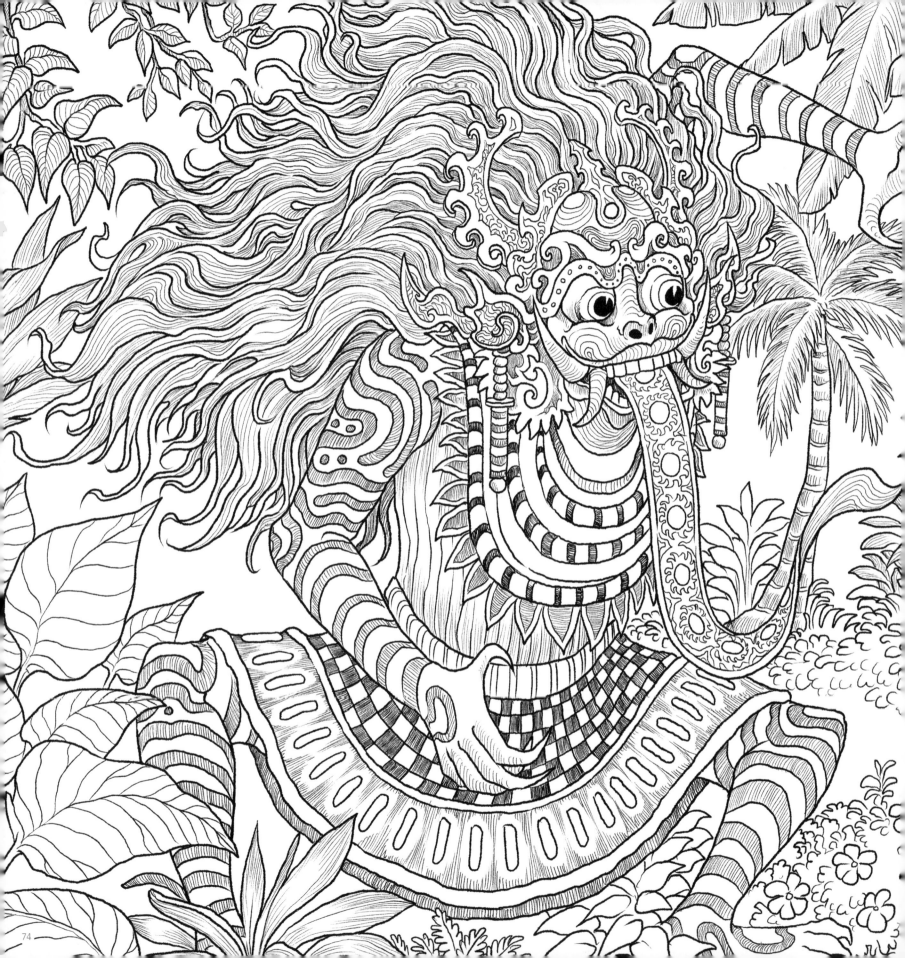

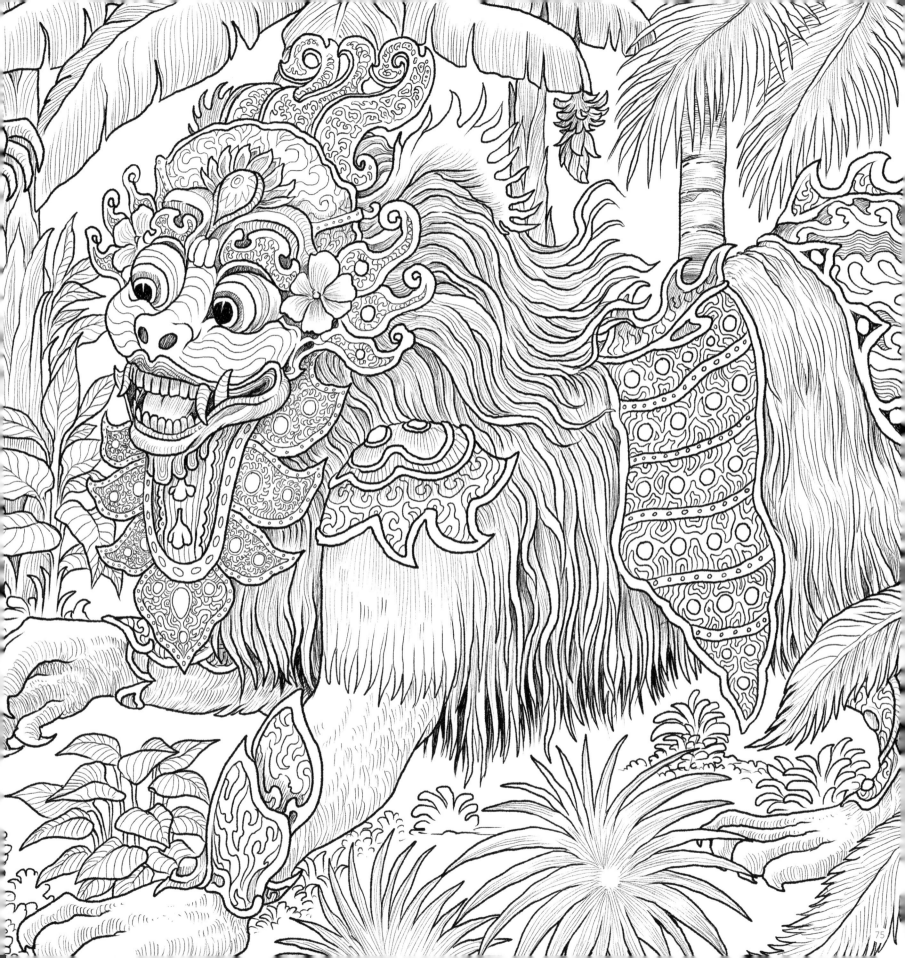

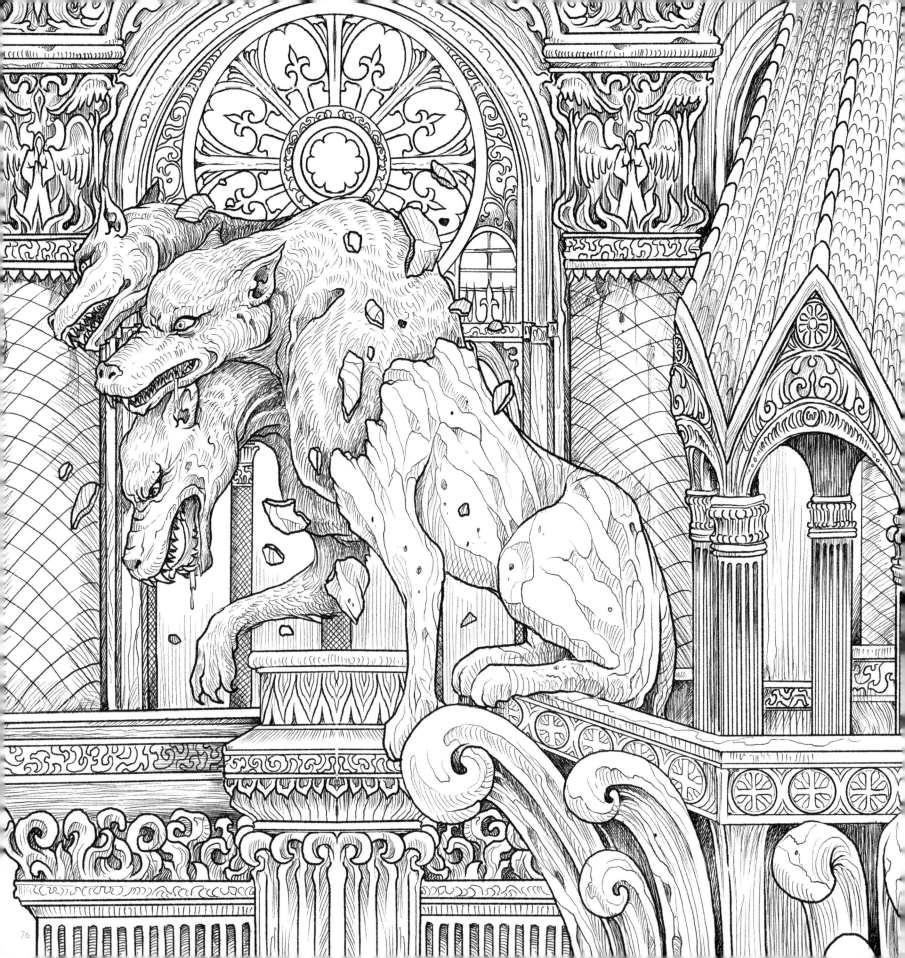

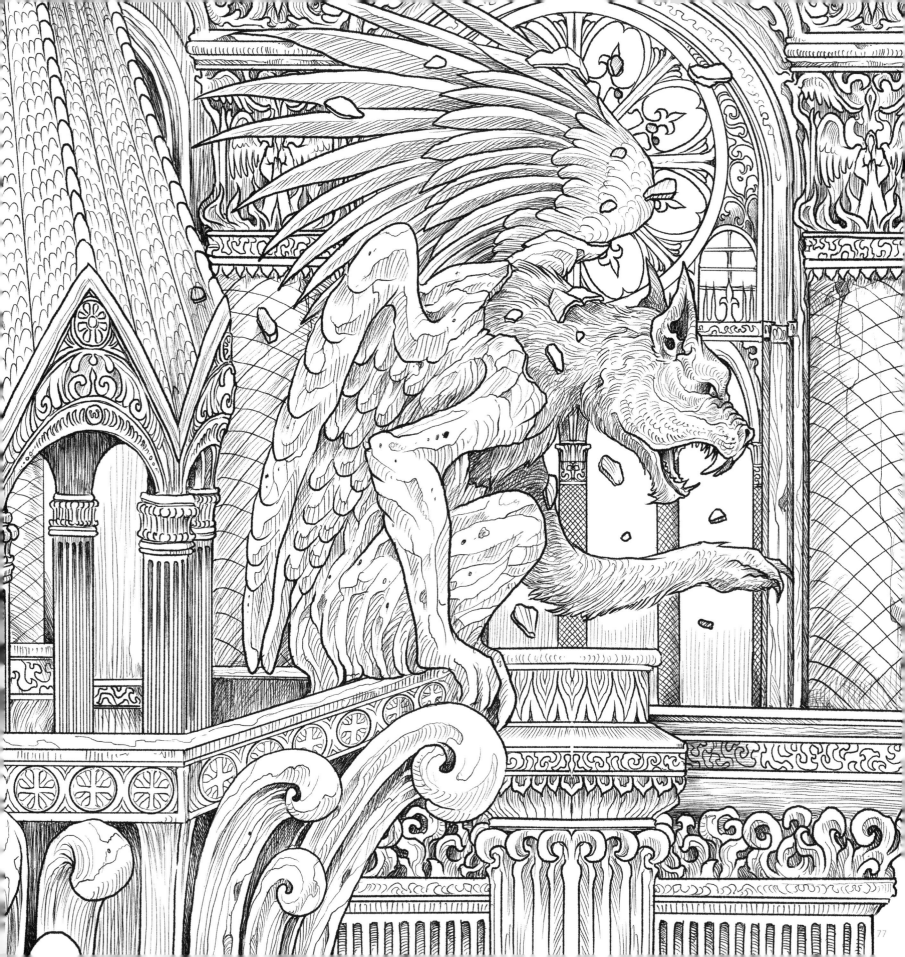

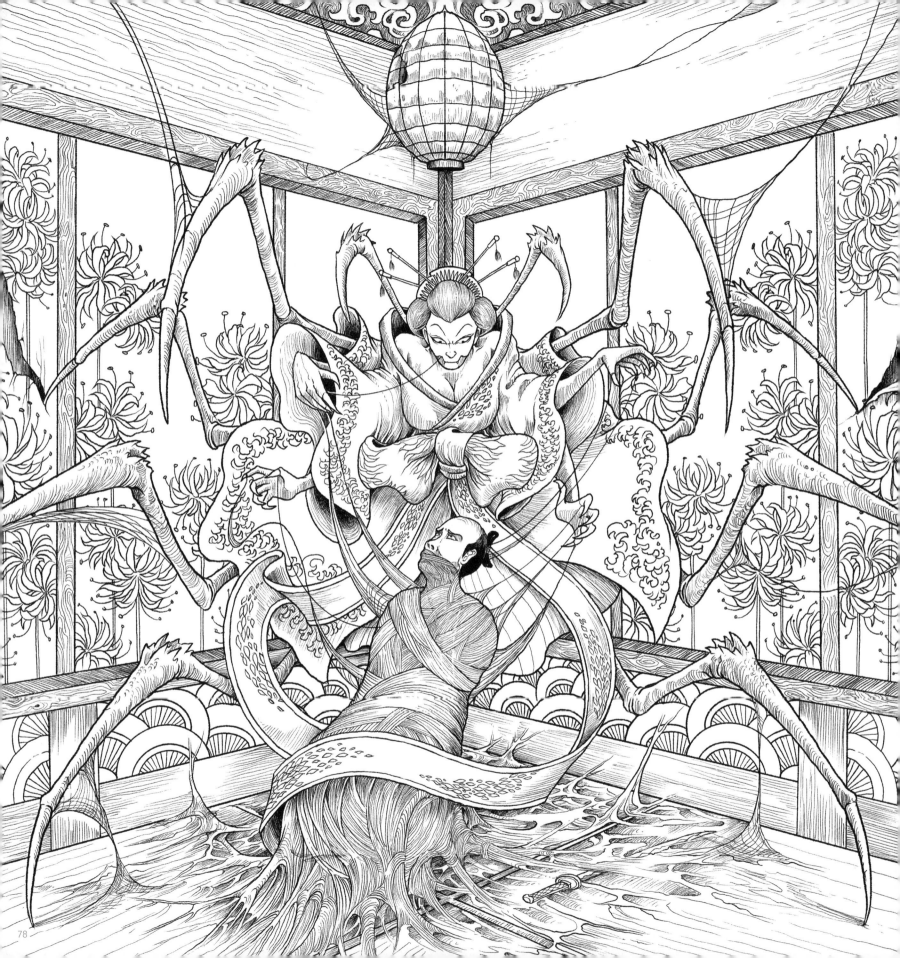

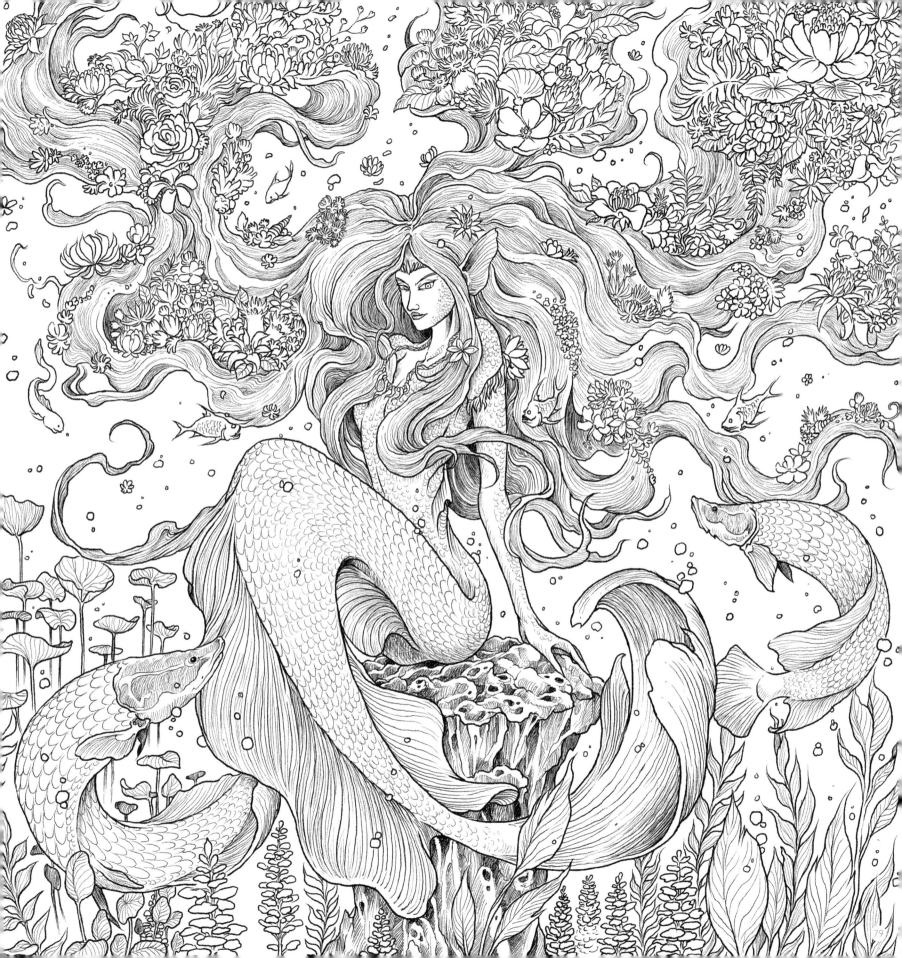

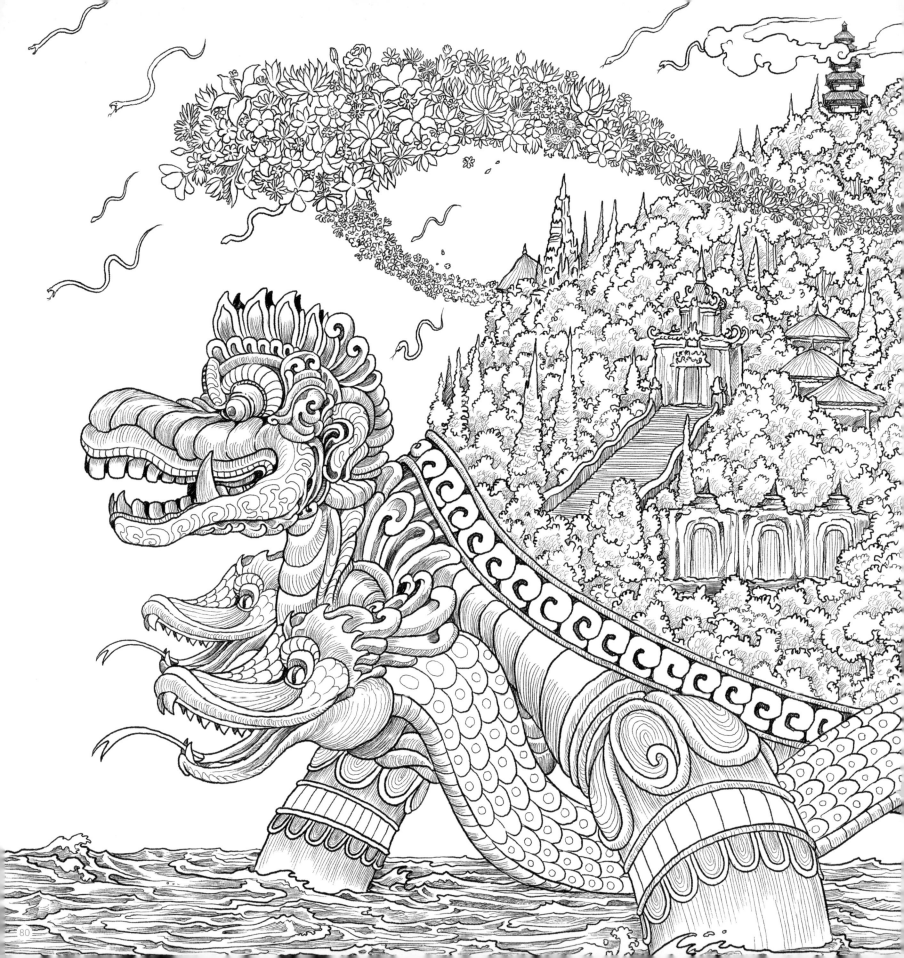

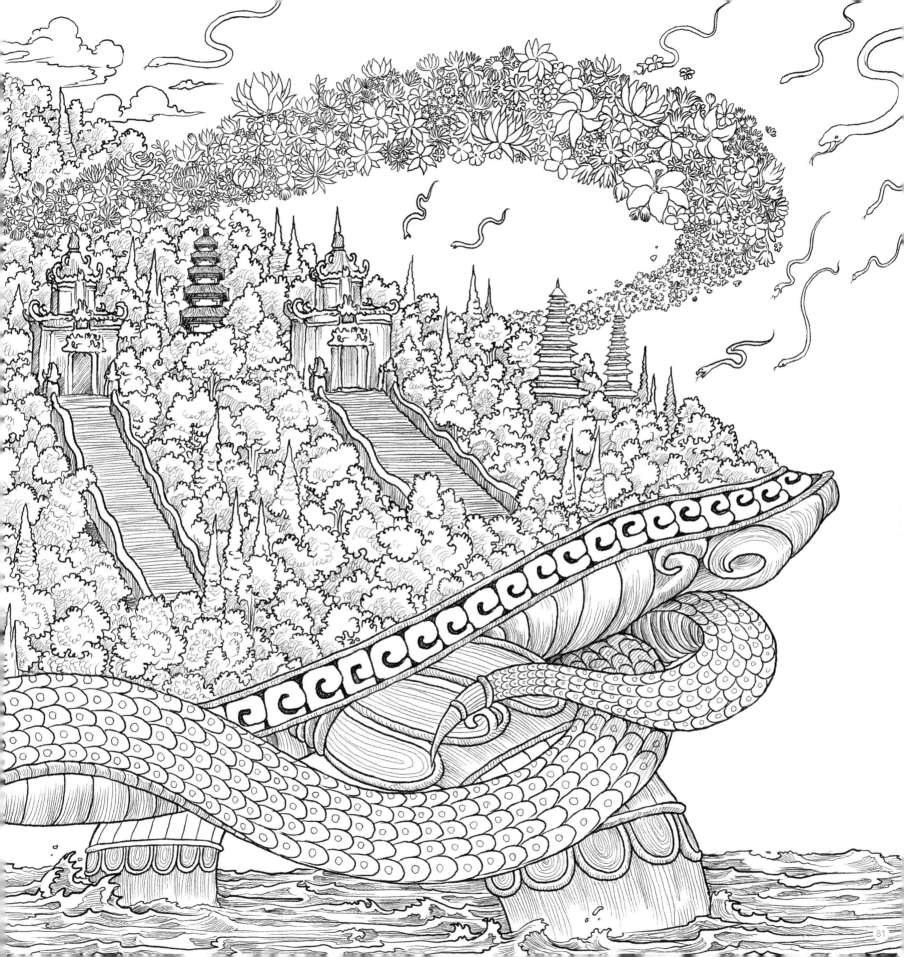

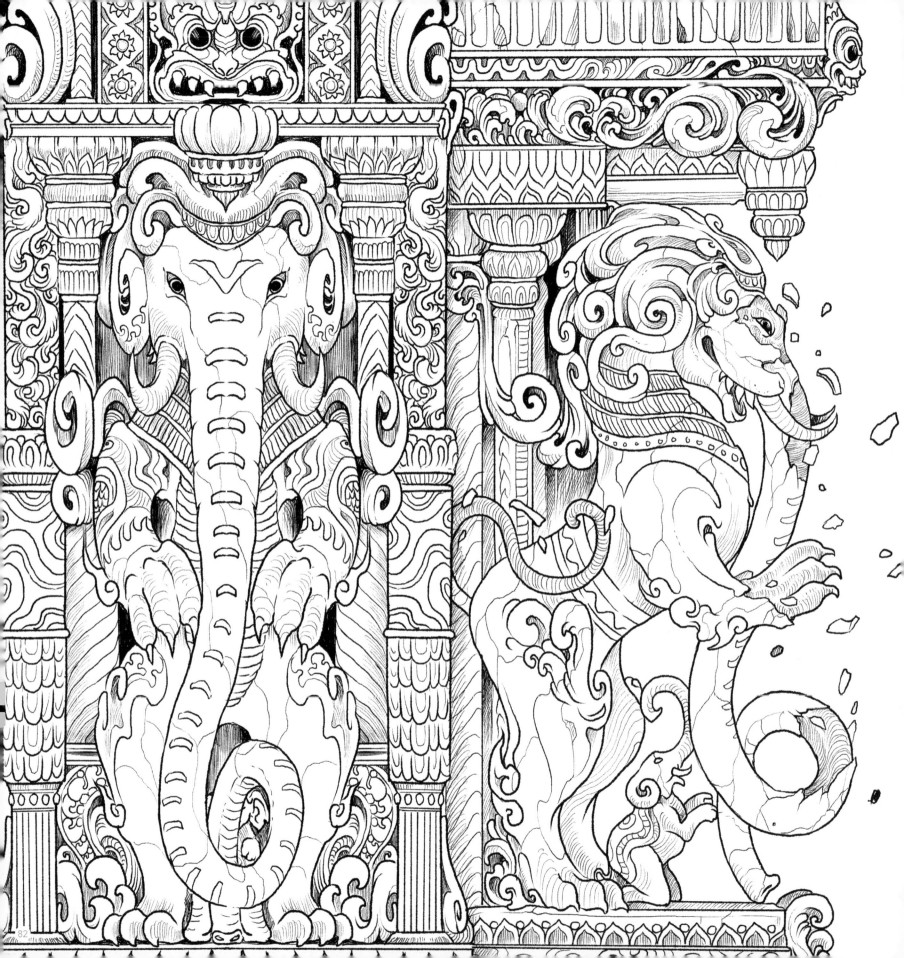

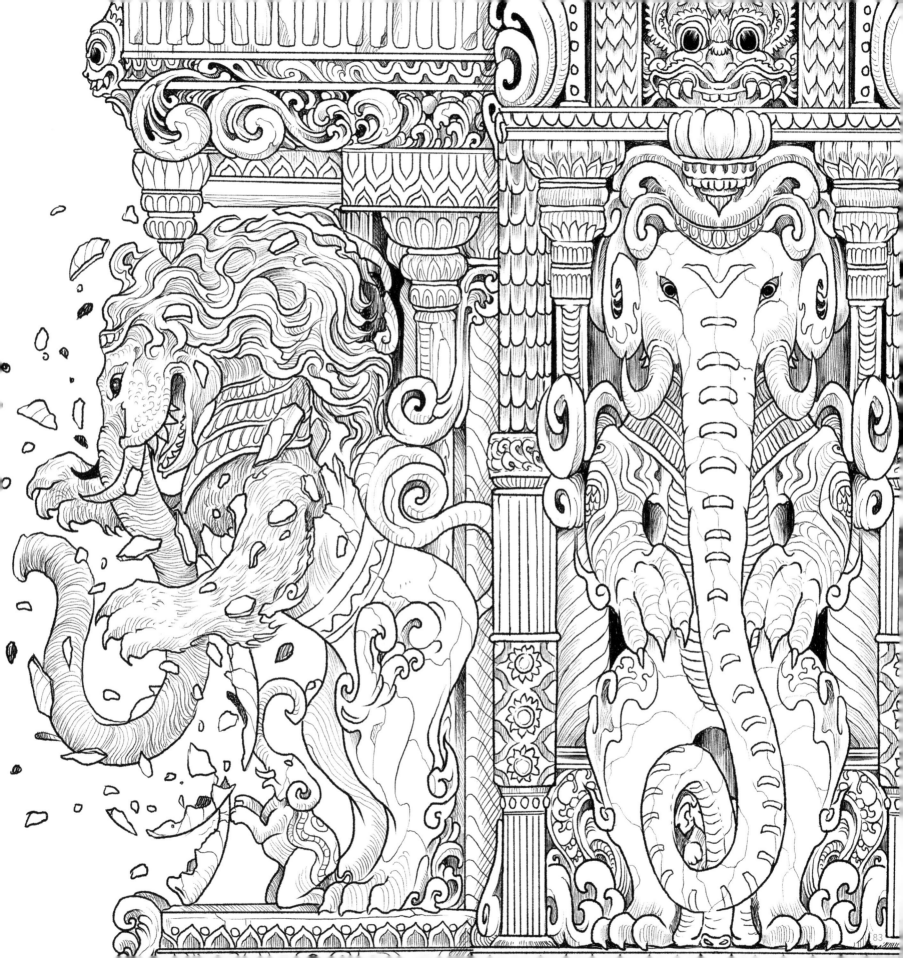

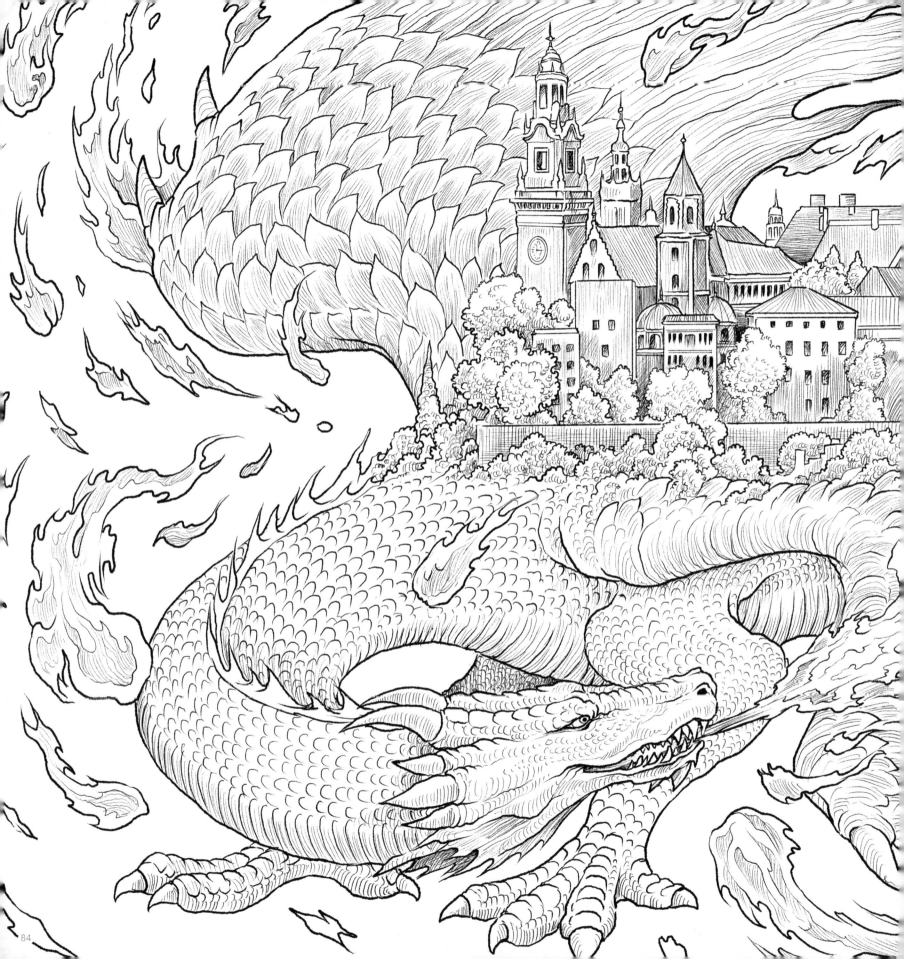

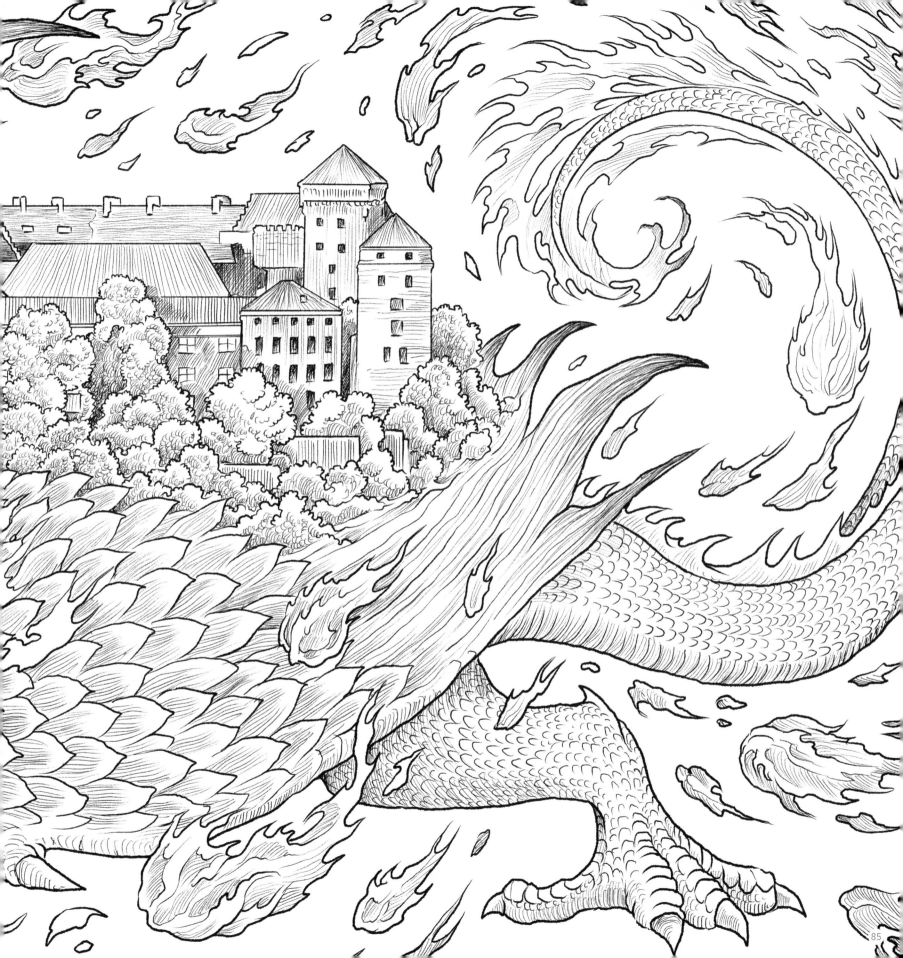

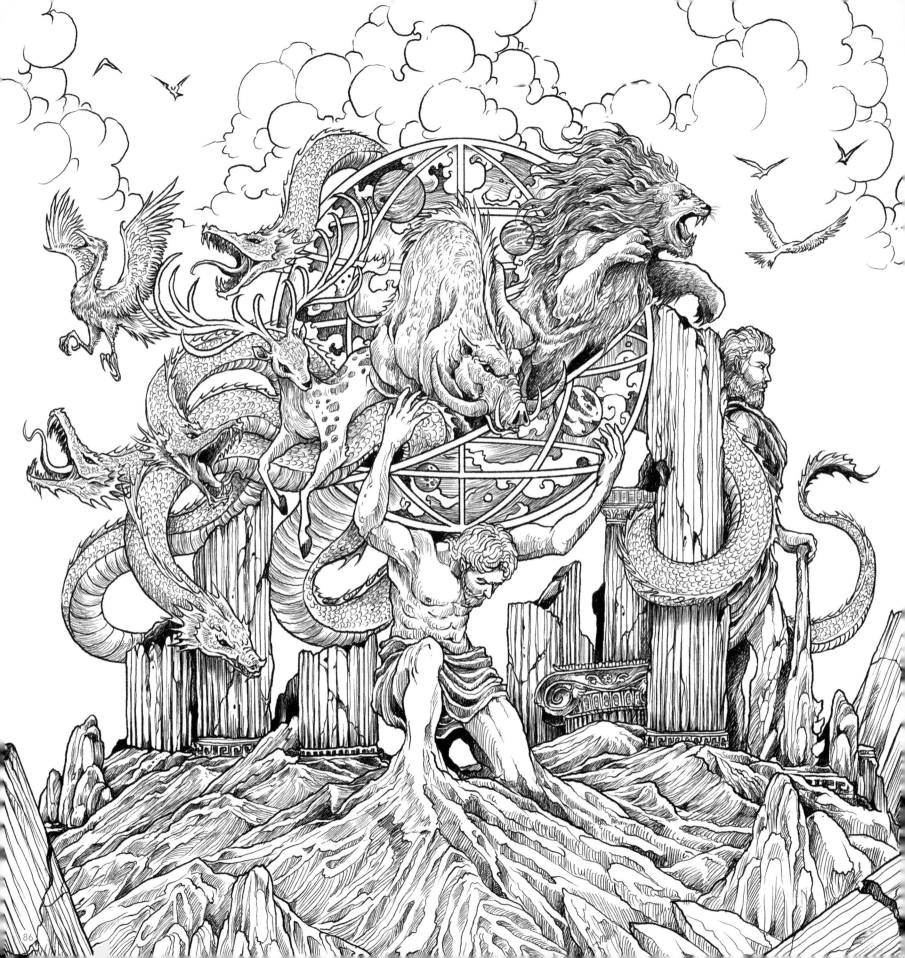

ABOUT THE MYTHS

MEDUSA—GREECE (P. 1)

In Greek mythology, Medusa is one of three powerful Gorgon sisters. She was once a beautiful maiden before she was cursed by Athena, resulting in her serpentine locks and a face that turns anyone who looks at it to stone. Following the curse, the Greek hero Perseus was ordered by the king to retrieve Medusa's sought-after head. The gods shrouded Perseus in protective armor, including winged boots, a cape of invisibility, and a shield forged by Athena. Using the polished shield's reflection, Perseus was able to sneak up on Medusa and decapitate her. With the monster's severed head in a sack and Medusa's enraged sisters hot at his heels, Perseus made a swift exit with the help of his god-given gifts.

FIONN MAC CUMHAILL AND BENANDONNER— THE GIANT'S CAUSEWAY, NORTHERN IRELAND (PP. 6–7)

According to legend, the magnificent stone columns on the coastline of Antrim are the remains of a huge causeway that connected it to Fingal's Cave on the Scottish island of Staffa. The causeway was built by the giant Fionn Mac Cumhaill in his attempt to defeat his Scottish rival, Benandonner. Their story is depicted in the fragmented landscape; you can see it in the causeway's stepping-stone-like columns that protrude from the sea at heights of up to twelve meters. These columns were believed to be created by Fionn tearing out and hurling chunks of the coastline across the sea. A misdirected throw from Fionn is now the Isle of Man, and a lost shoe can be seen in a huge, boot-shaped rock.

WHITE STAG—EAST ASIA (P. 8)

In one East Asian folktale, a group of indigenous hunters were chasing a white stag through a forest. They followed it for days on end, moving into increasingly unfamiliar territory. They eventually cornered the stag at the edge of a lake, but it leapt into the water and vanished from sight. Gazing despondently across the water, the hunters soon realized that the stag had led them to a far better reward: the lake was full of fish. The hunters and their families relocated to settle on the lakeshore, where they lived out the rest of their lives as fishermen.

SARUGAMI—MATSUMOTO CASTLE, JAPAN (P. 9)

Sarugami are wicked monkey spirits from Japanese folklore. They look and behave like wild monkeys but are much bigger, highly intelligent, and wear human clothes. They are considered fallen gods—once worshipped as mountain deities or messengers of the Sun. Monkey worship faded over time, and the sarugami degenerated into supernatural spirits, known as "yōkai," and became the opponents of samurai and heroes in Japanese mythology. Many myths involve the sarugami kidnapping young women from villages and being hunted down and killed by a local hero figure. Sarugami are said to reside in the Japanese Alps, where Matsumoto Castle, one of Japan's most iconic buildings, is also located.

THOR—THÓRSMÖRK, ICELAND (P. 10)

In Norse mythology, Thor is the son of Odin and the god of thunder. He is described as red-bearded and one of the strongest gods, second only to his father. He is the defender of Asgard and Midgard—two of the nine realms in Norse mythology—and many myths tell of his battles with frost giants and the Midgard sea serpent, Jörmungandr. Thor's weapon, forged for him by dwarfs, is a short-handled hammer called Mjöllnir. Thórsmörk is a valley and mountain ridge in Iceland that is believed to have been formed by Thor striking down his hammer into the rocky landscape.

MINOKAWA—PHILIPPINES (P. 11)

Tho minokawa is a hugo, dragon liko bird from Philippino mythology. It appears in the solar and lunar eclipse myths of the Bagobo people, where its feathers are likened to razor-sharp swords, its eyes to mirrors, and its beak and talons to solid steel. It is said to patrol the skies, waiting for its chance to capture and swallow either the Sun or the Moon. When it does so, and the Bagobo people are plunged into darkness, they scream, terrifed that the minokawa will come for the Earth next. But the cries of the people startle the creature into releasing the celestial body, and all is well until the next time the minokawa strikes.

TYPHON—MOUNT ETNA, SICILY, ITALY (PP. 12–13)

Typhon is a winged, fire-breathing storm-giant from Greek mythology. He is the son of Gaea, the personification of the Earth, and Tartarus, the personification of the underworld (the land of the dead). He has 100 heads and coiled serpents for legs. After countless battles, Typhon was eventually defeated by one of Zeus's thunderbolts, which smashed him down to Earth and trapped him under Mount Etna. Volcanic eruptions are said to be caused by Typhon trying to escape from imprisonment beneath the mountain. The chimera (pp. 24–25) and Scylla (pp. 44–45) are among his many offspring.

KAPPA—JAPAN (PP. 14–15)

According to traditional Japanese folklore, kappa are mischievous water demons that dwell in rivers, lakes, and ponds. On the top of a kappa's head there is a hollow indentation that holds a pool of water that is the source of its supernatural powers. If spilled, it can lose its powers and may even die. Kappa are most likely to use their powers for mischief or even violence, but they occasionally help humans, too. The simple act of offering a cucumber, with which they have a curious affinity, is enough to ensure protection from them.

KRAKEN—NORWEGIAN AND GREENLAND SEAS (P. 16)

The kraken, a legendary sea monster from Scandinavian folklore, is said to dwell off the coasts of Norway and Greenland. There it sleeps at the bottom of the sea, only rising to the surface when hungry. It creates huge ripples and whirlpools in the water that suck in ships and tear them apart. The creature is believed to be so huge that when its body emerges from the water, it can be mistaken for an island or a small cluster of islands.

BABA YAGA—NORTHERN RUSSIA (P. 17)

Baba Yaga is an ogress from Slavic folklore. She is said to live in the birch forests of northern Russia, in a hut that spins around on chickens' legs. The fence is constructed from human bones and lined with skulls. She rides through the air, sitting in an iron kettle or mortar, pushing herself along with a giant pestle. In the popular Russian fairy tale "Vasilisa the Beautiful," Vasilisa is ordered by her evil stepmother to collect light from Baba Yaga's hut. The cunning witch promises Vasilisa the light she needs on the condition that she complete a series of impossible tasks.

RIVER SNAKE—HORSESHOE FALLS, CANADA (PP. 18–19)

"The Maid of the Mist" is a traditional Iroquois tale. In a popular adaptation of the myth, a huge river snake plans to poison the water of the Niagara Falls, and then feed on the people that drink from the river. Lelewala (the "maid") warns the people of the snake's fatal plan and tells them to flee the village. Lelewala's true love, Henim, the thunder god, kills the beast with a single lightning bolt before it can do any further damage. The snake collapses into the water, its body obstructing the flow of the river and forming the Horseshoe Falls.

BUNYIP—NOOSA RIVER, AUSTRALIA (PP. 20–21)

The bunyip is a legendary water monster from Australian Aboriginal folklore. Descriptions of its appearance and character vary, but a common interpretation is of a gentle, shaggy-furred herbivore. Cryptozoologists have claimed that the creature actually existed at one time, owing to the discovery of strange fossils and alleged sightings in the 1840s and 1850s. It is said to inhabit inland swamps, waterholes, and lagoons, with some legends describing it as a protector of Australia's wildlife. The ancient everglades in Noosa are rich with native flora and fauna. One stretch of the everglades is named "The River of Mirrors" because of the vivid reflections on the water's surface—a result of the tannin-stained waters and lack of current and large watercraft.

DRUK—MOUNT EVEREST, HIMALAYAS (P. 22)

The druk is a dragon primarily from Bhutanese mythology. It is said to live in the remote areas of Mount Everest; its roar is attributed to the thunder that echoes across the mountains. Bhutan is known as "Druk Yul," or "Land of the Thunder Dragon," When the Ralung Monastery was built, there was a violent storm, and the thunder was interpreted as the roar of the great dragon. The druk is a national symbol, featuring on Bhutan's national flag and in the national anthem. Bhutan's leaders are known as the "Druk Gyalpo"—the dragon kings.

ROC—MADAGASCAR (P. 23)

In ancient Arabic mythology, the roc is a gargantuan bird of prey with a particular appetite for full-grown elephants. Its feathers are likened to giant palm tree fronds and its wings, each spanning an extraordinary fifteen meters, are capable of creating powerful cyclones. In *The Thousand and One Nights*—a collection of Arabic folktales—Sinbad the Sailor finds himself stranded on a tropical island following a shipwreck. He ties himself to the roc's leg and the bird flies to the Valley of Diamonds. The deep, rocky valley is filled with diamonds and jewels, protected by giant, poisonous snakes. The tropical island at the beginning of the story was thought to be the roc's home and identified by many, including Marco Polo, as the island of Madagascar.

CHIMERA—YANARTAŞ, TURKEY (PP. 24–25)

In Greek mythology, the chimera is a three-headed, fire-breathing creature. It has a lion's head and body, a goat's head emerging from its back, the udders of a goat, and a serpent or dragon as its tail. Mount Chimera was a place in ancient Lycia, now thought to be an area in Turkey called Yanartaş, which translates as "flaming stone." Here, dozens of small fires have been burning from vents in the side of the mountain for more than 2,500 years. The ancient Greeks believed the fires were a result of the chimera's breath. According to legend, the creature was defeated by the hero Bellerophon, under the orders of King Iobates of Lycia. Ruins of the temple of Hephaistos, the Greek god of fire, are also situated on Mount Chimera.

NIX—SØRVÁGSVATN LAKE, FAROE ISLANDS (P. 26)

The nix is a shape-shifting creature from Faroese folklore that commonly takes the form of a beautiful horse. It lures its victims toward the water before dragging them beneath the surface. One myth tells of two young boys, Niclas and his younger brother, Hanus, who once spotted the creature drinking from the lake. Niclas climbed onto its back, and the creature started running toward the deepest part of the lake. Hanus cried out after them, "Brother Nics, Brother Nics!" as he struggled to pronounce his brother's name. The nix loses its power when its name is called, and so with Hanus's cry the children were able to escape. Today, a statue of the nix can be seen at Sørvágsvatn lake, the largest lake in the Faroe Islands.

ASKAFROA—SKÅNE, SWEDEN (P. 27)

The askafroa is spoken of in Scandinavian folklore, particularly in Skåne, southern Sweden. She is a dryad—a spirit that lives inside trees. The askafroa is described as both the wife and the soul of the ash tree. Her existence is bound entirely to the tree—any harm committed to one is experienced by the other. She is a malevolent being, and anyone who so much as breaks a branch from the tree risks mortal illness. It is said that every year on Ash Wednesday, to appease the askafroa, a village elder would pour water on the roots of the tree and utter a recitation to implore that she bring them no harm. The ash tree is widespread in Scandinavian folklore, the most well-known example being the sacred "world" tree Yggdrasil, from Norse mythology.

FINFOLK—EYNHALLOW ISLAND, ORKNEY, SCOTLAND (PP. 28–29)

The finfolk are sinister shape-shifting creatures from Celtic mythology that emerge from the sea and abduct humans. They are amphibious, so they are equally at home on land as they are in the water. In the summer, they are said to live on a paradisiacal island called Hildaland ("Hidden Island"). The island is surrounded by a magical fog that engulfs travelers and lost ships, removing them from the mortal world. Many people in Orkney identify Hildaland with the real, uninhabited island of Eynhallow.

QILIN—CHINA (PP. 30–31)

In Chinese mythology, the qilin is a gentle, unicorn-like creature that appears shortly before the birth or death of a sage or respected ruler. According to legend, one of the earliest sightings of a qilin was at the birth of Confucius, a renowned Chinese philosopher. The creature is described as having a single horn on its head, a multicolored back, a yellow belly, the body of a deer, and the tail of an ox. It is depicted either with scales or flames covering its body. In the 1400s, Chinese sailors gifted a giraffe to the Ming emperor Yongle, mistaking the horned herbivore for the mythical qilin.

THE MOIRAI—GREECE (P. 32)

The three Moirai—known in English as the Fates—are the incarnations of destiny. They control the fates of all living things and are represented in Greek mythology by three women. Clotho (the "spinner") spins the thread of life. Lachesis (the "allotter") measures life's length. Atropos (the "inflexible") cuts the thread, determining the moment of death. The Fates were only deceived once, when the god Apollo learned that his favorite, Admetus, was destined to die. Apollo got the Fates drunk and persuaded them to spare Admetus's life. The Fates agreed but demanded someone else take Admetus's place. Admetus's wife, Alcestis, agreed to step forward and sacrificed herself for her husband's life.

KUMIHO—KOREA (P. 33)

In Korean folklore, it is said that special foxes exist that can live unnaturally long lives of hundreds or even a thousand years. After their long lives, these foxes transform into a type of cunning, supernatural fox spirit called a kumiho, which often takes the form of a beautiful woman. With every additional one hundred years they live, an extra tail sprouts, until they have nine in total. The kumiho shares similar characteristics with the Japanese kitsune and the Chinese huli jing. While the kitsune and huli jing have a more ambiguous moral compass, the Korean version is purely bloodthirsty, prowling graveyards to feast on human hearts.

BAKE-KUJIRA—THE SEA OF JAPAN (PP. 34–35)

In Japanese mythology, bake-kujira are the skeletal spirits of slaughtered whales. Said to reside in the Sea of Japan, they bring powerful curses to the coastal fishing villages they visit, spreading famine, plague, and fire. In many stories, the bake-kujira are hunted by fishermen. However, the fishermen's nets are no match for the whales' ghostly bodies. Instead, they pass mysteriously through them, and even harpoons are deflected without causing any harm. The waters around them swarm with strange fish, and the sky fills with mysterious birds. The terrified fishermen soon return home.

ĪTZPĀPĀLŌTL—CENTRAL MEXICO (P. 36)

Ītzpāpālōtl is a skeletal warrior goddess from Aztec mythology. She serves as the mother figure of the Aztecs and watches over women in childbirth. She is a powerful sorceress and rules over the paradise world, Tamoanchan, the place where the victims of infant mortality are sent. It is also where the gods first created humans, using bones stolen from the underworld. Ītzpāpālōtl is identified with the species *Rothschildia orizaba*, a saturniid silk moth, and her own wings are tipped with blades of obsidian, a type of volcanic glass. She has jaguar claws on her hands and eagle talons for feet, but she has the power to take many different forms.

PATUPAIAREHE—WAIPOUA FOREST, NEW ZEALAND (P. 37)

Patupaiarehe are supernatural beings from Māori mythology. They are described as having a similar build to ordinary people, and they like to sing and play bugle flutes. They are active at night and on foggy days, as sunlight is harmful to them. They are hostile to humans and live deep in New Zealand's forests and mountains. In this picture, the patupaiarehe are depicted in the Waipoua Forest next to the giant kauri tree, Tāne Mahuta. One of the largest trees in the world, Tāne Mahuta is over seventeen meters tall and spans more than four meters in diameter. The tree is named after the Māori forest god and is prominent in many Māori myths.

YAKSHA—WAT PHRA KAEW, BANGKOK, THAILAND (P. 38)

In Hindu mythology, yakshas are shape-shifting nature spirits that hide in the earth and tree roots. They are powerful magicians and considered the guardian deities of natural treasures. Their character is dubious, at times described as benevolent, at others capricious and even murderous. Yaksha sculptures are a common trait in ancient Buddhist and Hindu temple architecture. Wat Phra Kaew, the Temple of the Emerald Buddha, is considered the most sacred Buddhist temple in Thailand. Six of the temple's entrances are flanked by giant yaksha guardians.

KUBERA—MOUNT KAILASH, CHINA (P. 39)

Kubera is the king of the yakshas (see above) and the god of wealth and prosperity. He is commonly depicted as a plump figure with a big belly. He is often shown holding a money bag or a pomegranate, and in Buddhist sculptures he may be accompanied by a mongoose. According to the Vedas—a collection of ancient Hindu religious texts—Kubera built and ruled the golden city of Lanka (now Sri Lanka) until he was forced out by his half brother, the demon Ravana. Kubera is now said to live in a beautiful mountain residence near the god Shiva's home on Mount Kailash, in the Himalayas. Kubera and the yakshas are also popular figures in Buddhist and Jain mythology.

LANDVÆTTIR—ICELAND (PP. 40–41)

Landvættir are protective spirits of their native land. Today, the belief in landvættir is still strong in Iceland, where parts of the landscape are protected to ensure the spirits are not disturbed. The four guardians of Iceland are said to protect its four quarters: the Dreki (dragon) in the east, the Gammur (eagle) in the north, the Griðungur (bull) in the west, and the Bergrisi (giant) in the south. In *Heimskringla*—a collection of Old Norse sagas—King Harald "Bluetooth" Gormsson of Denmark sends out his wizard's spirit in the form of a whale to determine the best points of Iceland from which to attack. One by one, the spirit comes face-to-face with the four guardians, each as fiercely threatening as the last. Today, landvættir feature on the Icelandic coat of arms, on Icelandic króna, and on the national football team's crest.

GRIFFIN—CARPATHIAN MOUNTAINS, EUROPE (PP. 42–43)

With the back legs and body of a lion and the wings and beak of an eagle, the griffin in Greek myths inhabited mountaintops in northern Scythia (now believed to be the Carpathian Mountains). The griffins were highly skilled at finding gold and used their strong beaks to mine through rock. They also laid eggs that contained gold nuggets. A race of one-eyed people, the Arimaspi, resided in the foothills. The Arimaspians made frequent attempts to steal from the griffins, which incited animosity between them. The tribe were no match for such powerful beasts, and lost much more than they gained in battle.

SCYLLA AND CHARYBDIS—STRAIT OF MESSINA, ITALY (PP. 44–45)

In Greek mythology, Scylla and Charybdis are sea monsters that haunt the Strait of Messina, between Sicily and mainland Italy. They were once beautiful water nymphs before they were transformed into sea monsters by their jealous rival, the sorceress Circe. Scylla haunts the cliffs on one side of the strait; she has a voice like yelping dogs and six long necks. Each of her mouths is lined with three rows of sharp teeth. Charybdis resides on the other side under a huge fig tree. She is personified as a whirlpool, swallowing and regurgitating the sea three times a day. The strait is fatal to passing ships, as described in Homer's *Odyssey*— sailors who veer too far to one side risk Scylla's snapping jaws; too far to the other and the entire ship is in danger of being swallowed by Charybdis.

TROLLS—REYNISDRANGAR, ICELAND (P. 46)

Off the coast of Reynisfjara in Iceland, a cluster of hexagonal basalt formations protrude from the North Atlantic Ocean, reaching heights of 66 meters above the water. These sea stacks, known as Reynisdrangar, are said to be the remains of a family of trolls. According to legend, the trolls once rested on the black-sand beach at night. They spotted a ship out on the stormy waters and waded out to pull it toward land. But disaster struck: with the break of dawn, the trolls were turned to stone before they reached the shore. It is believed that if you walk near the cliffs today, you will be able to hear the petrified trolls crying out for their home in the mountains.

PHOENIX—ANCIENT ARABIAN SPICE GROVES (P. 47)

In ancient Greek and Egyptian mythology, the phoenix is a long-lived bird with powers of regeneration. It flies west from Elysium—the afterlife realm for great heroes—into the mortal world, stopping at Arabian spice groves to gather frankincense and cinnamon for its aromatic nest of wood. Safe in its nest as the Sun god rises, the phoenix turns east to face him and sings a beautiful, haunting melody. The phoenix and its nest are then engulfed in flames. After the fiery combustion, a new phoenix is born and rises from the ashes. The young phoenix, once it is strong enough, embalms the ashes in myrrh and takes them to Heliopolis ("City of the Sun") in Egypt.

AQRABUAMELU—MESOPOTAMIA, IRAQ (PP. 48–49)

The aqrabuamelu are gigantic scorpion men from Babylonian mythology. They have the head, body, and arms of a man and the lower body of a scorpion, with huge, arching tails loaded with venom. They are formidable archers, and even their stare can prove fatal. They are said to guard the gates at Mount Mashu, where the Sun god Shamash lives between the mountain's twin peaks. Here, the aqrabuamelu warn travelers of the danger that lies in the dark land ahead. In the *Epic of Gilgamesh*, they question the hero-king Gilgamesh at the entrance to the mountain. They deduce from his answers that Gilgamesh must be part god, and grant him passage through the long, dark tunnel.

SPHINX OF BOEOTIAN THEBES—GREECE (P. 50)

The Sphinx of Thebes has the head of a human, the body of a lion, and the wings of a vulture. According to Greek legend, it was summoned from Ethiopia and instructed to terrorize the city of Thebes in Greece. As travelers approached, it would demand an answer to the following riddle: "What is it that has one voice and yet becomes four-footed and two-footed and three-footed?" If the traveler failed to solve the riddle, the Sphinx would eat them. The correct answer is "man," who crawls on all fours as a baby, walks on two feet as an adult, and uses a walking stick in old age.

MAMI WATA—WEST AFRICA (P. 51)

Mami Wata is a water spirit and deity who has been both worshipped and feared across African cultures and in the African diaspora since ancient times. She is the protector of the water kingdom and a force of good fortune and fertility. She is usually accompanied by a large snake, a symbol of divinity. She is said to stalk the ocean shores of West Africa, abducting passersby who are out swimming or traveling by boat. If she deems them worthy, the goddess returns them to the shore with a changed attitude toward spirituality. Today, some people in Cameroon believe that Mami Wata is the reason behind the strong underwater currents along the coast, which many swimmers are lost to each year.

CHERUFE—CHILE (PP. 52–53)

The cherufe is a lizard-like creature from Mapuche mythology, said to inhabit magma pools in Chilean volcanoes. Its body is made from rock crystals and magma, and it has the ability to summon powerful earthquakes and volcanic eruptions. These seismic events can only be prevented by offering the cherufe a sacrificial victim for it to feast on. Thrown into the bowels of the cherufe's fiery home, the victim wouldn't stand a chance against the terrifying beast. When the cherufe is finished with its meal of human flesh, it sets fire to the disembodied head and hurls it from the mouth of its volcano toward the terrified people below.

RAINBOW SERPENT—AUSTRALIA (PP. 54–55)

In Aboriginal mythology, the rainbow serpent is the creator of all life and the protector of the land and its people. Though it has the power to bring regenerative rain, the serpent can also cause storms, floods, or droughts if not respected. As the serpent travels through a network of underground waterholes, a rainbow can be seen in the sky, their curves mirroring each other. As it weaves its way across the land, the serpent blesses the people and ensures the areas it visits are not affected by the onset of drought. Earliest representations of the rainbow serpent are found in cave paintings in Arnhem Land, in Australia's Northern Territory, and are somewhere between 6,000 and 8,000 years old.

ALKONOST AND GAMAYUN—RUSSIA (PP. 56–57)

Alkonost and Gamayun are powerful spirits from Slavic and Old Russian folklore. They are described as having the heads of beautiful women, the bodies of birds, and hypnotic singing voices. Alkonost is the bird of the dawn. She rules the winds and weather and lives in the underworld. Her singing voice brings joy to good souls and pain to evil ones. She lays her eggs on the beach and then rolls them into the sea, which she ensures is gentle and calm. When the eggs hatch, thunderstorms break out and the waters become too rough to cross. Gamayun is a symbol of wisdom and knowledge. She delivers prophecies and divine messages from the gods, and lives on an island in the mythical east, close to paradise.

ANGGITAY—SANTO TOMAS, PHILIPPINES (P. 58)

In Philippine mythology, the anggitay has the upper body of a woman and the lower body and legs of a horse. She has a single horn in the middle of her head and carries a bow and arrow for hunting. She hoards precious gemstones and wears sparkling jewelry. The anggitay is said to live alone or in small groups in Santo Tomas, at the foot of the sacred Mount Makiling. She is an excellent climber, finding safety in the branches of large trees where she can sleep and keep watch. It is said that anggitay are the daughters or female counterparts of the tikbalang—another breed of human-horse hybrids with more sinister temperaments, which prowl the dense, dark wildlands of the Philippines.

VARENGAN—IRAN (P. 59)

The varengan is a type of magical raven from Persian mythology that acts as the messenger of Mithra, the god of the Sun. It is described as being the fastest of all birds and its feathers are used as protective charms against harmful spells and curses. The varengan travels to Mount Damavand, Mithra's home, which is believed to be the center of the world and is steeped in myth and magic. It is a semi-active stratovolcano and the highest peak in Iran. The varengan is also one of the many forms taken in battle by Verethraghna, the Persian god of war and victory.

PRICOLICI AND STRIGOI—BRAN CASTLE, ROMANIA (PP. 60–61)

Romania's sweeping landscapes are central to its rich mythology and tradition of oral storytelling. Transylvania in particular is said to be home to a host of mythical creatures that roam the mountains and dense forests. Legends of pricolici and strigoi are widespread in the folk imagination, and Bran Castle is associated with sightings of both creatures. Pricolici are likened to werewolves, and strigoi to vampiric spirits. Both of these devilish creatures are said to be the undead souls of violent or malevolent men, risen from their graves to prowl and haunt the landscape. Legends of the strigoi became the inspiration for Bram Stoker's well-known Gothic horror novel, *Dracula*.

THE FOUR GUARDIANS—CHINA (PP. 62–63)

In ancient Chinese astronomy, four mythological creatures guard the four corners of the world and sky. Qīnglóng, the Azure Dragon, is the guardian of the east, and represents the element of wood and the season of spring. It controls the rain and represents benevolence and creativity. Zhūquè, the Vermilion Bird of the south, represents fire and the summer season. It controls heat and flame and symbolizes propriety. Báiyu, the White Tiger in the west, represents the element of metal and controls the wind. It represents the season of autumn and serves as a protector of the righteous. Xuánwu, the Black Tortoise in the north, is associated with water and the season of winter. It controls the cold and is symbolic of knowledge.

ISIS—EGYPT (P. 64)

In ancient Egyptian religion and mythology, Isis is the goddess of maternity and healing, and the divine protector of the dead. She is commonly depicted with a headdress bearing the hieroglyphic sign of the throne. According to myth, her husband and brother, Osiris, the king of Egypt, was murdered by their jealous younger brother, Seth. Isis gathered and bandaged Osiris's scattered body and, once restored, installed him as lord of the underworld. Isis gave birth to a son, Horus, who banished Seth and restored order to the mortal world. Scenes from this myth are etched into the walls of the temple of Isis, which was built on the island of Philae during the Ptolemaic dynasty. After the flooding of Lake Nasser, it was moved to Pompeii, Italy. Today, it is considered one of the best-preserved Egyptian temples.

NØKKEN—TÅRNTJERNET LAKE, NORWAY (P. 65)

The nøkken is a shape-shifting water spirit from Norwegian folklore. In true form, he is described as a grotesque, moss-covered creature with glowing yellow eyes, razor-sharp teeth, and skin like a drowned corpse. Out of water he can take the form of an elegant gentleman, playing enchanting music on his fiddle. His other forms include a horse and an old wooden rowboat. He is said to live in Tårntjernet, an idyllic forest lake full of water lilies, located on the island of Jomfruland. Some tales tell of the nøkken falling in love with a human and living on land, only to become unhappy, yearning for his former life in the water. In most tales, however, he is seductive and malicious, luring women and children to their deaths with his spellbinding music.

RAINBOW FISH—INDIA (PP. 66–67)

According to Hindu mythology, the rainbow fish—which was the size of a whale and adorned with colorful scales—swam the seas and oceans of the world. Its scales represented the classical elements: green scales made of grass to symbolize the earth; blue scales made of ice to represent water; yellow scales made of lightning to represent air; and red scales made of flames to symbolize fire. According to the legend, when searching for food one day, the rainbow fish approached and devoured Buddha, an incarnation of the god Vishnu. Local fishermen caught and killed the rainbow fish, freeing Buddha from its stomach, and providing food for a whole nation for a year.

GROOTSLANG—RICHTERSVELD, SOUTH AFRICA (PP. 68–69)

The grootslang, which features in South African mythology, is a type of gigantic serpent with the trunk, tusks, and ears of an elephant. These monsters are believed to have been created by the gods themselves at the beginning of the world. However, the gods realized they had made a terrible mistake by making something so vicious, strong, and insatiably hungry. They decided to split the grootslangs into two separate creatures: the elephant and the snake. One grootslang escaped and is said to live in the Richtersveld in South Africa, deep within a cave filled with diamonds and jewels.

ONI—JAPAN (P. 70)

In Japanese folklore, oni are demonic, troll-like creatures that are born when wicked humans die. They are described as red, pink, or blue-gray in color, and are commonly depicted with horns, wild hair, and fang-like tusks. They wear loincloths made of the pelts of great beasts and stand taller than the tallest man. Oni are immensely strong and ferocious in nature. They exert their powers of sorcery for purely evil means, spreading disaster and disease wherever they go. Despite possessing supernatural powers, they still brandish huge iron clubs to use on their victims whenever they please. They are said to reside in remote mountain caves and abandoned houses.

HECATONCHEIRES—GREECE (P. 71)

The hecatoncheires are three giants from Greek mythology, each with one hundred hands and fifty heads. They are the sons of the primordial titans, Uranus and Gaea, and the brothers of the cyclopes, the masters of thunder and lightning. The hecatoncheires control the clouds with their hands and the wind with their heads. They were recruited by Zeus to help drive the elder gods from heaven down into the pit of Tartarus. The rise of the constellation Ara (the altar) marks the annual opening of the gates of Tartarus and therefore the beginning of the stormy season in Greece. The unleashing of the hecatoncheires and cyclopes from the underworld brings powerful gales and lightning storms.

PÚCA—IRELAND (P. 72)

The púca is a nature spirit from Irish folklore, considered to be a bringer of both good and bad fortune. It often takes the form of a black horse or adopts the ears or tail of a rabbit, fox, or wolf. The púca enjoys creating havoc, enticing humans to climb on its back before taking them on a wild ride from which they never return. The creature is associated with Samhain, a Celtic pagan festival that marks the end of the harvesting season. It is believed that the rotting of blackberries is the result of the púca spoiling the crops on Halloween every year. The púca is said to live in open mountainous areas across Ireland. A number of small lakes and springs in the mountains have been named "Púca Pools," many of which are at the sources of major Irish rivers.

CHANG'E AND THE MOON RABBIT—CHINA (P. 73)

Chang'e is the goddess of the Moon in Chinese mythology; the Moon rabbit is her companion and the guardian of all wild animals. The Moon rabbit's duty is to pound the goddess's elixir of immortality, a concoction of herbs that Chang'e stole from her husband on Earth. Markings on the Moon are said to resemble the outline of a rabbit in a standing posture; typical paintings of Chang'e show her floating toward the Moon with her palace in the background. The Moon Festival is a traditional Chinese festival that falls around mid-September, when the Moon is believed to shine at its brightest and fullest. Tables are piled high with mooncakes, and lanterns are released into the sky, to commemorate the stories of the Moon goddess and her rabbit.

BARONG AND RANGDA—BALI, INDONESIA (PP. 74–75)

In Balinese mythology, Barong is king of the spirits and the symbol of health and good fortune. His antithesis and enemy is Rangda—the Demon Queen and leader of evil witches. The Barong mask dance is a traditional performance that portrays the eternal fight between Barong, representing good, and Rangda, representing evil. Barong is commonly portrayed as a lion covered in thick fur and wearing jewelry embellished with mirror shards. Rangda is portrayed as a hideous fanged witch with a lolling tongue and wild hair. Barong and Rangda engage in a struggle, with Rangda casting black magic on the dancers, sending them into a trance of self-destruction. Barong uses protective magic to keep the dancers safe, and in the final battle, Barong is victorious and order is restored.

GOTHIC GROTESQUES—NOTRE-DAME DE PARIS, FRANCE (PP. 76–77)

Notre-Dame de Paris is considered one of the most beautiful Gothic cathedrals in the world. From its construction in the thirteenth century, the cathedral's exterior was gradually adorned with gargoyles and grotesques. Gargoyles are designed to keep rainwater away from the cathedral's sacred walls, and are also considered deterrents to evil spirits. Grotesques lack any functional quality and simply serve as decorative sculptures. The types of creatures and their temperaments range from nonchalant herons to fearsome wyverns—winged dragons. Popular sculptures include the three-headed dog and the famous Styrga chimera, the latter of which is first referenced in Ovid's *Fasti*.

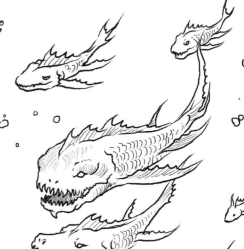

JORŌGUMO—JŌREN FALLS, JAPAN (P. 78)

Jorōgumo is a yōkai from Japanese mythology. She takes the form of a spider but has the ability to shape-shift into a beautiful woman. She preys upon handsome young men, seducing them and then binding them in strong silk threads. She weakens them with her venom to ensure a slow and painful death. Jorōgumo sometimes calls on her entourage of small, fire-breathing spiders to help ensnare her prey. One legend tells of a man who is resting by the Jōren Falls in Izu when he feels a sticky web on his leg. Knowing that the Jorōgumo is about to drag him to his doom, he transfers the web to a nearby tree stump, which subsequently gets pulled into the water instead, saving him. In other legends men are not so lucky, disappearing into the water, never to be seen again.

IARA—SOLIMÕES RIVER, BRAZIL (P. 79)

In Brazilian folklore, Iara is a siren who lures men into the water with her irresistible song and beauty. According to legend, she was once a fierce and highly-skilled warrior—something that made her two brothers deeply envious. The brothers plotted to kill Iara, but she discovered their plan and killed them first in defense. Fleeing through the forest, she was hunted down by her father, who threw her into the Solimões River in the Amazon. The river fish saved her and transformed her into an immortal sea creature. Today, the river is said to be her home. She sits on a rock and sings, brushing her green, flower-adorned hair and attracting the attention of male passersby before dragging them to the depths of the river.

BEDAWANG—BALI, INDONESIA (PP. 80–81)

When time began—according to the Balinese creation myth—only the "world serpent," Antaboga, existed. But through meditation, Antaboga created Bedawang, a giant turtle. Two dragons lie on Bedawang's shell, providing stability for the Earth that rests on her back. When Bedawang moves, there are earthquakes and volcanic eruptions, and she also carries the Black Stone—the gateway to the underworld. Above the human world, there are several layers of sky: first a watery sky; then a moving sky, where the god of love, Semara, lives; the next is a dark blue sky, which holds the Sun and Moon; then a scented sky full of flowers, where snakes known as the Awan fall like shooting stars. The ancestors live in a fiery sky farther above, and the gods occupy the final sky that rests over all others.

YALI—MEENAKSHI TEMPLE, INDIA (PP. 82–83)

The yali is a creature from Hindu mythology, often portrayed as part lion, part elephant, and part horse. Sculptures of the yali are common across ancient temples in southern India and are believed to protect their entrances and halls. With the rise of the Madurai Nayak dynasty from the mid-1500s, a unique style of temple architecture emerged. Meenakshi Temple, located in the city of Madurai, is an examplar of this style, and was once nominated to be one of the Seven Wonders of the World for its spectacular design. The yali is the dominating feature in one of the temple's many halls, the Ayirakkal Mandapam. The name translates as the "hall with a thousand pillars"—each one is carved with images of the yali.

WAWEL DRAGON—KRAKÓW, POLAND (PP. 84–85)

According to Polish folklore, a dragon once lived in a cave at the foot of Wawel Hill in Kraków. The dragon demanded food from the city with increasing fussiness, until the king finally had enough. He offered his daughter's hand in marriage in return for the dragon's head. Countless men died in vain, until a young apprentice named Skuba devised a cunning plan to use the dragon's gluttony against him. He filled a lamb's body with sulphur, placed it at the mouth of the dragon's lair, and set it alight. The dragon gulped down the lamb and exploded. Today, large bones—believed to be the remnants of the dragon—hang from the gargoyles at the entrance to the city's cathedral, and a metal "fire-breathing" sculpture stands beside the River Wisła.

ATLAS—GREECE (P. 86)

Atlas, in Greek mythology, is a Titan—one of the gods that ruled the universe before being overthrown by Zeus and the Olympians. When the Titans were banished to Tartarus, the lowest part of the underworld, Atlas was condemned to carry the Earth and heavens on his shoulders for all eternity. He appears in the myth of the Twelve Labors when, on one of his labors, Heracles is tasked with stealing golden apples from the garden of the Hesperides. Heracles offers to take the Earth from Atlas's shoulders in exchange for Atlas fetching the apples from his daughters. Atlas willingly agrees, eager for an opportunity to escape his enslavement. But when he delivers the apples, Heracles tricks Atlas into taking the Earth back, leaving Atlas once again with the weight of the world on his shoulders.